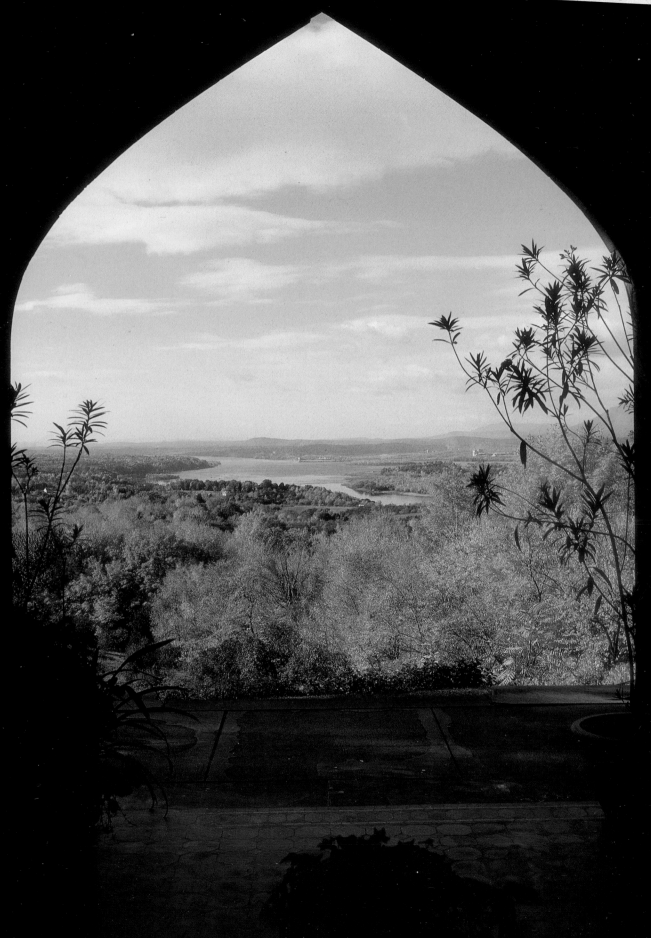

Frontispiece: View from the Court Hall, through the Ombra, to the Hudson River and Catskill Mountains beyond,
1970 © Neefus Photographers.

FREDERIC CHURCH'S
OLANA

ARCHITECTURE AND LANDSCAPE AS ART

JAMES ANTHONY RYAN

Introduction by
FRANKLIN KELLY

BLACK·DOME

1011 Route 296, Hensonville, New York 12439
Tel: (518) 734-6357 Fax: (518) 734-5802 www.blackdomepress.com

First Edition Paperback, 2001

Black Dome Press Corp.
1011 Route 296
Hensonville, New York 12439
Tel: (518) 734-6357
Fax: (518) 734-5802
www.blackdomepress.com

Library of Congress Cataloging-in-Publication Data:

Ryan, James Anthony,
 Frederic Church's Olana: architecture and landscape as art / James Anthony Ryan ;
 introduction by Franklin Kelly.
 p. cm.
 Includes bibliographic references and index.
 ISBN 1-883789-28-1 (trade paper)
 1. Church, Frederic Edwin, 1826-1900—Homes and haunts—New York
 (State)—Hudson. 2. Olana State Historic Site (Hudson, N.Y.) 3. Painters—United
 States—Biography. I. Title.

ND237.C52 R93 2001
759.13-dc21
[B]

 2001035083

Design by Carol Clement, Artemisia, Inc.

Printed in the USA

Front Cover: Photograph, *Olana*, 2000 © Kurt Dolnier.
Back Cover: Frederic Edwin Church, *Catskill Mountains from the Home of the Artist*, 1871,
oil on canvas, 22 1/8 x 36 3/8 in.
Heading Motif: Detail from southwest bay window, Olana.

ACKNOWLEDGMENTS

Visitors to Olana regularly request a publication with more information about the house and site. Finally, thanks to the dedication and skills of many individuals, we have *Frederic Church's Olana*. The major author of this book, James Anthony Ryan, was Olana's Site Manager from 1979 until his untimely death in 1999. For twenty years, Jim devoted his professional life to Olana. To everyone he met, he conveyed a joy and exuberance for the site that was heartfelt and sincere in the most singular way. This love of Olana is powerfully evoked in his essay, and we all feel privileged and proud to publish this book in his memory.

As chairman of The Olana Partnership, I want to thank the many people and organizations who have contributed to this enterprise. At the start, board members and I express grateful appreciation to David Seamon, Evelyn Trebilcock, and Jacqueline Wilder—the Olana Partnership Publications Committee. We especially thank Chairman Jacqueline Wilder, who persistently believed in this project and diligently worked to make the book a reality. We are grateful to Olana Curator Evelyn Trebilcock, who worked assiduously to coordinate text and visual images. Without Evelyn's unflagging efforts and professionalism, this book could not have been completed. Special thanks also go to Pauline Metcalf of the Felicia Fund and Edward Lee Cave for their generosity in helping to underwrite this publication. We are particularly grateful to Joan Davidson and Furthermore, the publication program of the J. M. Kaplan Fund. In addition, we thank Bruce McPherson for publishing advice and Armin Allen, Chairman of the Olana Curatorial Committee, for his belief in this project and for his invaluable assistance in fundraising.

We also express thanks to the New York State Office of Parks, Recreation and Historic Preservation, particularly the staff persons who contributed to this effort. At Olana, Historic Site Manager III Linda McLean and former Interpretative Program Assistant Heidi Hill provided continuous help and support. Assistant Parks and Recreation Activities Specialist Georgette Turner carefully checked the text and the book's chronology of Frederic Church and Olana for errors. Also ready to assist were the staff at the New York State Bureau of Historic Sites at Peebles Island, including James Gold, John Lovell, Anne Cassidy and Ronna Dixson. We are especially grateful for their locating visual images owned by New York State and for waiving the costs of reproduction.

In the production of the volume, there are many individuals and institutions deserving thanks. Sara Griffen, The Olana Partnership's president, has been a tireless advocate of this project from the very beginning. Olana's Librarian and Archivist Ida Brier coordinated the edited corrections of the manuscript and checked the accuracy of innumerable facts. First Olana site manager Richard Slavin, landscape architect Robert Toole, history educator Natalie Daley, and long-time Olana supporter Trudy Huntington graciously reviewed sections of the manuscript for historical

accuracy, and Trudy provided a number of important photographs relating to the saving of Olana in the early 1960s collected by her late husband, art historian David Huntington. We also thank Mrs. Lloyd Boice for providing us access to photographs of her late husband, who also played a major role in saving the site.

Other people helped with visual images in the book, including the Metropolitan Museum of Art's Julie Ceftel, the Cooper-Hewitt's Jill Bloomer, the Cleveland Museum of Art's Mary Lineberger, the Rockefeller Archive Center's Michele Hiltzik, and the Corcoran Gallery's Elizabeth Luchsinger. We are especially grateful to photographer Peter Aaron for allowing us to reproduce his beautiful photograph of the house; and to photographer Kurt Dolnier for his exceptional interior images of the house and for the glorious photograph on the book's front cover.

In regard to writing, organizing, and publishing this book, there is yet another group of individuals and institutions to be thanked. We are grateful to Debbie Allen and her staff at Black Dome Press, who have encouraged us during the long months of work and who have produced a book we all agree is worthy of James Ryan and Olana. Copyeditors Matina Billias, Patricia H. Davis and Steve Hoare helped prepare the manuscript text for publication, and we thank Carol Clement of Artemisia, Inc. for her artful design. We thank Franklin Kelly, Curator of American and British Paintings at the National Gallery in Washington, D.C., who found time in his busy schedule to write the elegant introduction to the book and who also served as our liaison with the National Gallery to make possible the reprinting and updating of James Ryan's essay.

In planning this book, we felt that the history of Olana should be continued to the present, since so many visitors wonder how such an unusual property was able to survive after Frederic Church's death in 1900. To provide this remarkable story, we drew on the expertise of Karen Zukowski, former Olana curator, and David Seamon, a writer who co-authored with James Ryan the introductory exhibit panels in Olana's visitor's center. Seamon was James Ryan's life partner for fourteen years, and he also played a major role in revising and updating Ryan's original essay and in envisioning, editing, and coordinating the manuscript as a whole. Out of his love for Jim and Olana, David has selflessly worked on this project and has exhorted us all to do the absolutely best job possible.

In short, this project has involved enormous effort and coordination and, on behalf of The Olana Partnership, I thank all who have contributed so enthusiastically and skillfully. The book is a labor of love for James Ryan and for Olana. May you, the reader, be edified and touched.

—Kay Toll
Chairman, The Olana Partnership
Hudson, New York
2001

TABLE OF CONTENTS

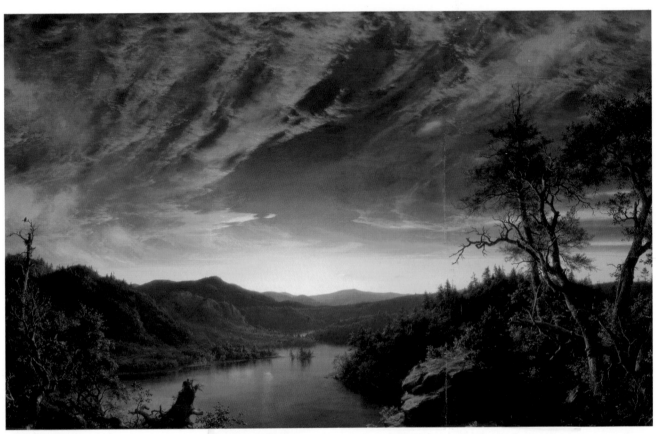

Figure 1. Frederic Edwin Church, *Twilight in the Wilderness*, 1860, oil on canvas, 40 x 64 in., The Cleveland Museum of Art, Mr. and Mrs. William H. Marlatt Fund.

FREDERIC CHURCH'S OLANA
AN INTRODUCTION

When Frederic Edwin Church died in 1900, one writer noted that his name, although once famous throughout America, was likely to be confused with that of the younger (and today largely forgotten) artist Frederick Stuart Church, a popular animal and figure painter. F. E. Church had, in fact, lived long past the era of his greatest popularity. His most important successes came early in life: he was accepted as Thomas Cole's pupil when he was eighteen, made his professional debut as a painter at New York's National Academy of Design at nineteen, and was elected to full membership in the Academy when he was twenty-three—still today the youngest artist ever so honored.

By the time he was thirty-three, Church had painted *Niagara* (1857) and *The Heart of the Andes* (1859), two of his most famous works. When he completed *Morning in the Tropics* (1877), his last truly successful major picture, he was only fifty-one. By contrast, his contemporary George Inness (1825-1893), a landscape artist who had struggled for recognition during the 1850s and 1860s, was from the late 1870s on hailed as America's greatest landscape painter. Church knew Inness's work, and he would have been perfectly well aware of, and troubled by, the shift in taste that had left him and his art behind.

The reasons behind Church's fall (if we may call it that—perhaps recession is a better word) from popular and critical acclaim can only be touched upon here. America's political and cultural history may well embody the familiar adage "the only constant is change," but this pattern was especially true in the years 1845-1865, when Church rose to fame. The era was marked by many momentous events and was bracketed by two explosive national conflicts—the Mexican-American War of 1846-1848 (which saw America aggressively expand its physical boundaries), and the Civil War of 1861-1865 (which divided the country before it had even reached its Centennial).

During this time, the world of science and natural history also underwent unprecedented turmoil. The idea of a rationally organized and implicitly understandable universe (epitomized by a book that deeply influenced Church, Alexander von Humboldt's *Cosmos: A Sketch of a Physical Description of the Universe*, the first volume of which was published in 1845) collapsed and was replaced by a new model in which nature was seen as a place of competition and struggle not governed by internal harmony and not automatically (some would have said divinely) progressing toward ever more improved and higher states. At the same time, the world of art in America was changing as the cultural influence of an old aristocratic elite in control in the 1820s and 1830s was replaced by a more populist and democratic taste that reflected the interests of swelling numbers of newly monied merchants and businessmen in cities across the land.

Frederic Church's meteoric rise in the 1840s and 1850s was fueled by the tumult of the times, for his landscapes managed to give pictorial voice to the

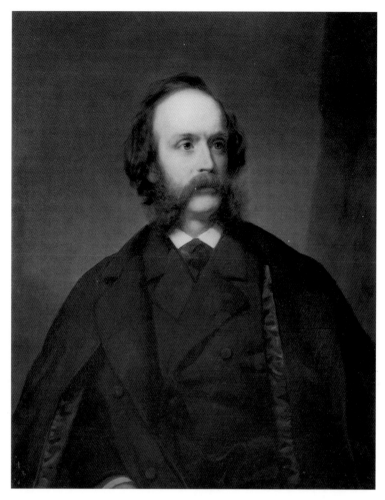

Figure 2. Charles Loring Elliot, *Frederic Edwin Church*, 1866, oil on canvas, 34 x 27 in.

political, social, and cultural issues that concerned many who saw his paintings. His constructions of ideal New England landscapes and dreamy South American arcadias spoke of the seemingly infinite riches of New-World nature at the same time as they reaffirmed humankind's right to use and enjoy those bounties. Church's unequaled ability to combine intricate, precise details with sweeping compositions was the aesthetic equivalent of Humboldt's view of the cosmos, which posited that one could know the greater whole only by careful study of its myriad parts. And Church's firm faith in the rightness of American national identity and its foundations in Protestantism would have resonated deeply with the admirers of his great paintings.

In fact, Church and his art were perfectly suited to the moment. As S. W. G. Benjamin wrote in *Harper's New Monthly Magazine* in 1879: "Our civilization needed exactly this form of art expression at this period, and the artist appeared who taught the people to

love beauty and to find it." But that moment would be brief. By 1865, much of what Church's art embodied had become outmoded at best and discredited at worst. Younger painters like Winslow Homer (1836-1910) eschewed grand landscapes in favor of smaller, more intimate (but no less profound) images of America's citizens in their various guises: soldiers, farmers, school teachers, and others. Landscape painting continued on in new forms such as the Barbizon-influenced work of George Inness, which downplayed detail and sweep in favor of suggestiveness and evocative poetry.

American taste, which before the Civil War had verged on the excessively chauvinistic, now underwent an abrupt correction that led it to seek excellence in all things foreign. Fewer and fewer people, including Church himself, would now look to the natural world in all its complexity as a transparent affirmation of divine order and wisdom.

Thus, there are many external reasons that might explain why Frederic Church withdrew from the limelight. But if we ask what personal reasons may have influenced his actions, there are also many possibilities. In 1860 he married, and that same year he began to acquire the property that would ultimately become the site for Olana. In 1862 his first child (Herbert Edwin Church) was born, followed in 1864 by his second (Emma Francis Church). Sadly, both children would die in the epidemic of diphtheria that swept the nation in 1865. Another son (Frederic Joseph Church) was born in 1866, but that joy can only have been tempered by the death of Church's younger sister, Charlotte Eliza, in January 1867.

By the time he was barely forty years old, Church had experienced profound loss. In 1868-1869 he traveled in the Near East, seeking, perhaps, some confirmation of the essential truths of life. We cannot know if he found what he sought but, upon his return to the United States, he turned his attention with extraordinary purpose and energy to the construction of a home and natural environment for his family that would become one of the greatest creations of its era.

James Ryan's essay in this book tells the story of the design and building of Olana thoroughly, eloquently, and with a deep understanding that was the result of long firsthand experience of the place and its wonders. As his words help us understand, Church achieved in this last great work of his life a thing of astounding complexity in its details, but remarkable harmony in its whole.

However one chooses to describe what Church did—the decades of work reshaping the landscape, building a house of unique design, and filling it with works of art, books, furniture, natural curiosities and much, much more—there can be no doubt that Church spent more time on the creation of Olana than he did on any other work of his career. Church could not have known it—his intentions were, after all, largely personal and directed to his family—but his efforts resulted in something that has gone on to reach and touch countless numbers of people long after his death.

The major paintings that Church created during the height of his career were manifestly public objects—things designed by him to be seen by large numbers of people and to have, ideally, a positive

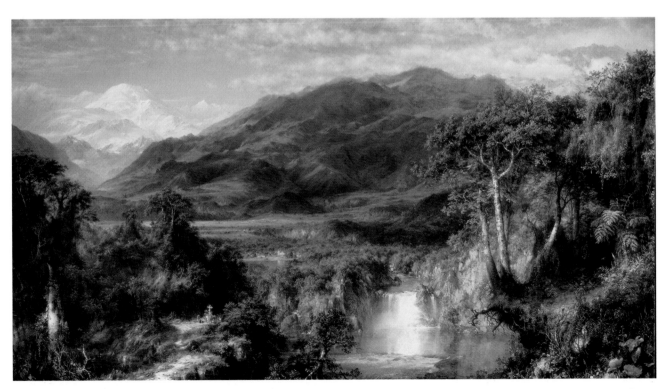

Figure 3. Frederic Edwin Church, *Heart of the Andes*, 1859, oil on canvas, 66 1/8 x 119 1/4 in., The Metropolitan Museum of Art, Bequest of Mrs. Davis Dows.

influence on them. By comparison, his devotion of most of his creative energies to Olana during the last three decades of his life (while publicly exhibiting his paintings only very rarely) might seem to embody a retreat from his public artistic persona and a disavowal of all that his art had represented.

As we have seen, there are external and personal reasons that can explain his retreat from the public eye, but nothing we know about Church in the years he concentrated on Olana suggests that he lost faith in what he so fervently held to be true before. Instead, Church's creation of Olana can be seen as his most fully expressed—at the same time that it is his most personally felt—statement on human beings' place in the natural world.

Just as Humboldt explained about the world as a whole, Olana is a myriad of details and facts organized into a rational whole by a presiding intelligence. Church created a world that was, for him and his family, a microcosm of the greater perfect whole. What he did at Olana was precisely the same as he had done years before in his paintings. Employing aesthetically what Ralph Waldo Emerson called "the vast and the intricate," Church demonstrated that the world was defined by human beings' presence in it, even as their presence in the world served to define them.

We are incalculably the richer for what Church made at Olana. In his creation, Church left to the world something extraordinary in its originality but also reassuring in its familiarity. Olana is a place where appreciative visitors can both feel their connection to the world at large and sense their own special place in it. It is a place where the past is palpably alive but where the present and the future are made special and inviting.

To say that Olana is the single most important artistic residence in the United States and one of the most significant in the world, is only to state the obvious. To say that it is a place of the rarest, most profound, and most moving beauty and complexity and that it is a place that must be experienced to be fully understood and appreciated, is more to the point. In the end, though, one can only say that Olana is unique.

—Franklin Kelly
Curator of American and British Paintings
National Gallery of Art, Washington, DC
2001

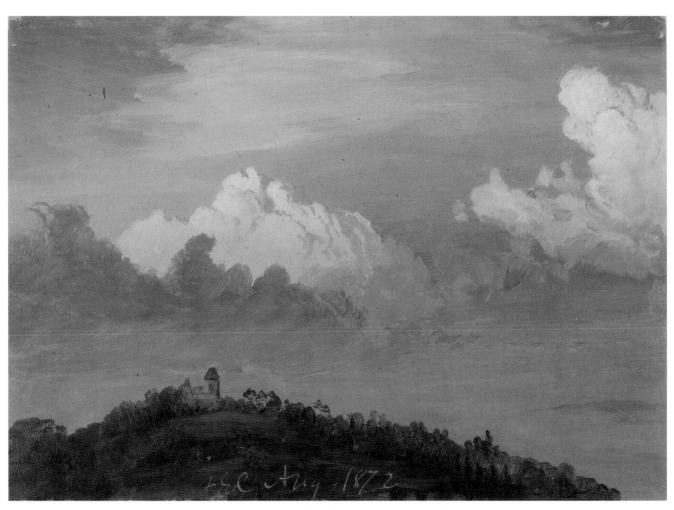

Figure 4. Frederic Edwin Church, *Olana in the Clouds*, 1872, oil on paper, 8 11/16 x 12 1/8 in. Olana is the Persian-style home and 250-acre ornamental farm of landscape painter Frederic Edwin Church. Splendidly sited on a hillside overlooking the Hudson River and the Catskills near Hudson, New York, the property was saved from dispersal through the efforts of David Huntington, Alexander Aldrich and the members of Olana Preservation, Inc. The State of New York purchased it intact in 1966 from the estate of Sally Church, the painter's daughter-in-law. Olana State Historic Site is operated by the New York State Office of Parks, Recreation and Historic Preservation.

CHAPTER 1
PAINTING, MARRYING, AND STARTING A HOME[1]

The harmonious union of buildings and scenery is a point of taste that appears to be but little understood in any country; and mainly, we believe, because the architect and the landscape painter are seldom combined in the same person or are seldom consulted together. It is for this reason that we so rarely see a country residence, or cottage and its grounds, making such a composition as a landscape painter would choose for his pencil.

—Andrew Jackson Downing[2]

The recollection of the blue mountains is as fresh and vivid to me as the day I last saw them," wrote twenty-year-old Frederic Church in the fall of 1846 to Thomas Cole, his former teacher.[3] Cole lived in the small Hudson River town of Catskill, New York, and Church studied with him from June, 1844, to May, 1846 (figure 5). During those two years, the blue Catskills became for Church, as they had been for Cole, "steps by which we may ascend to a great temple."[4] The Catskills formed the daily landscape of Church's life, and, as hundreds of his early sketches attest, the topography, trees, clouds, and skies provided the subject matter for his instruction as a landscape artist. In fact, the Catskills were the subject for his *Twilight Among the Mountains (Catskill Creek)*, one of the first two paintings he exhibited publicly at the National Academy of Design in 1845.

In May of that year, Cole took Church across the Hudson to sketch the spectacular view from a high shale bluff called Red Hill (figure 6). Three miles to the south, the Hudson widens into a lakelike expanse framed by the receding ranges of the Catskills and the Shawangunks beyond. During the 1830s, Cole had sketched this same view at least four times; the thin pencil sketch that Church produced that spring day portended his lifelong association with the landscape of the Hudson River and the Catskills.[5]

Figure 5. R. S. De Lamater, *Frederic Edwin Church*, c. 1855, carte-de-visite, 4 x 2 3/8 in., a photograph of a daguerreotype taken in 1844.

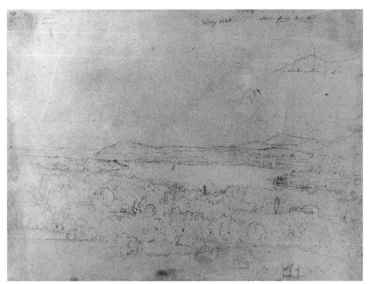

Figure 6. Frederic Edwin Church, *The Hudson Valley from Red Hill,* 1845, graphite on paper, 10 1/8 x 14 3/8 in.

After painting landscapes of the Americas, the Middle East, and Europe, Church would return to this spot and "pronounce the views most beautiful and wonderful."[6] He eventually chose the ridge of which Red Hill was a part as the site for his Hudson River home, Olana, a landscape and architectural work of art that, beginning in 1860, occupied his creative energies for over half his life.

<div align="center">

SUCCESS, MARRIAGE, AND
MAKING A FIRST HOME

</div>

After he left Cole and moved to New York City, Church advertised himself in the newspapers, wrote reviews of his own paintings, traveled in search of picturesque or sublime views, and eventually borrowed the British concept of a "great picture"—a large canvas depicting an important subject. In 1857, Church rose to international prominence with *Niagara* (figure 8). His next large painting, *The Heart of the Andes* (1859, figure 3), brought more than acclaim; he met his future wife, Isabel Mortimer Carnes, during the first public showing of this work in New York City. As friend and artist Worthington Whittredge records the story which reached him in Rome of the meeting, Church was "standing behind some of the rich draperies he had arranged around his picture" and glimpsed "a ravishing vision, a star illumined with a light never before seen on land or sea!"[7] Church introduced himself, and on 10 January 1860, the *Boston Evening Transcript* commented, "Church has

been successfully occupied with another Heart than that of the Andes."[8]

Born in Paris in 1836, Isabel Carnes (figure 7) was twenty-three years old and living in Dayton, Ohio, with her parents, who were originally New Englanders.[9] Years later, a contemporary remembered her as "a lovely flower—the realization of a Poet's dream. In her Maidenhood after her engagement, when her whole being was enlisted in admiration for the man of her choice, a new beauty developed, richer, deeper than that of the fresh young girl, and she grew more charming than before."[10] For the Yankee artist—reared in a stern Congregationalist household, the son of six generations of ministers and merchants—his engagement to Miss Carnes was "great cause ... for congratulations."[11] The couple were married in Dayton on 14 June 1861 by Louis LeGrand Noble, Thomas Cole's minister and biographer and one of Church's closest friends.

Four months before the wedding, on 31 March 1860, Church took time from painting *Twilight in the*

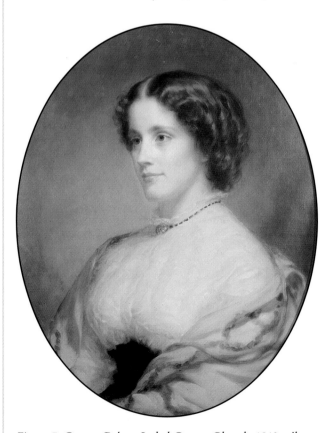

Figure 7. George Baker, *Isabel Carnes Church,* 1860, oil on canvas, 27 x 22 1/8 in.

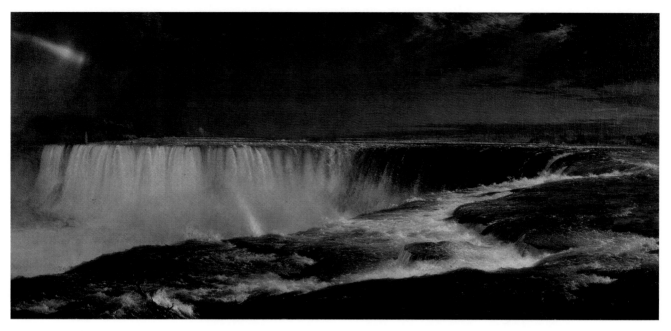

Figure 8. Frederic Edwin Church, *Niagara*, 1857, oil on canvas, 42 1/2 x 90 1/2 in., The Corcoran Gallery of Art, Washington, D.C.

Wilderness (figure 1, p.8) to travel up the Hudson River to purchase 126 acres of fields and woodlands known as the Wynson Breezy farm.[12] This property adjoined Red Hill, from which Church and Cole had sketched, but not until 1867 did Church acquire the higher summit on which he built his house. Although two contemporary accounts state that Church searched the shores of the Hudson for three years before selecting Wynson Breezy's farm as the site for a home, it seems inevitable that this location, associated with his formative years and with his mentor Cole, drew the artist to return.[13] A reporter visiting the property a few years later wrote that:

> The artist who, of all our artists, has the quickest eye for beauty has set his seal of choice on this part of the Hudson. Compared with its only rival, the Highlands, it is like maturity compared to youth. The abrupt wildness, the impetuous romance, and the concentrated prodigalities that make the very name of the "Highlands" ravishing to the imagination, are tempered here by lengthened approaches, more leisurely [illegible] heights and broader horizons, and so, if such a term may be allowed to scenery, intellectualized at Kaatskill.[14]

On this "intellectualized" landscape, Church created in three dimensions a personal vision of harmony between man and the American landscape. It was a vision created not by a showman to delight and instruct the American public, but by a husband making a home for a family. Standing on the escarpment in front of the Catskill Mountain House, the Reverend Theodore Cuyler glimpsed across the Hudson River "a patch of green no larger than a man's hand ... the spot on which the painter Church is gathering materials for his nest."[15]

The farmland that provided Church's earthy canvas included a swampy stream and fields that extended three-quarters of the way up the slope of the *Sienghenbergh*, or Long Hill, near the summit of which he would eventually build the main house. Church immediately began to construct a modest rural cottage designed by architect Richard Morris Hunt (1827-1896).[16] Frederic and Isabel Church occupied "Cosy Cottage," as it came to be called, in May or June of 1861 (figure 9). The farm was to be a place to rear their children. Herbert Edwin was born on 29 October 1862 and Emma Frances two years later on 22 October 1864. To celebrate their births, Church painted two works: *Sunrise* for the boy and *Moonrise* for the girl.[17] "Herbert enjoys the Farm as much as anybody," Church wrote to his father in 1864. "We have a coop of 15 chickens by the house and he feeds them out of his hand. ... I have a pair of pigeons—one of them today marched into the parlor to the great delight of Herbert."[18]

Figure 9. Unidentified photographer, *Cosy Cottage*, c. 1890, albumen print, 3 15/16 x 5 7/8 in.

From the beginning, Church hoped that "the farm," as the family called it, would serve as a retreat from an often-painful artistic celebrity. Painting at first in the cottage or in an outbuilding, Church erected a large wood-frame studio around 1864 at the topmost boundary of his property on Long Hill. He no doubt chose this location because it offered the site's broadest panoramas, which he depicted on paper and canvas many times between 1861 and the 1890s (figure 10). "I am appalled when I look at the magnificent scenery which encircles my clumsy studio, and then glance at the painted oil-cloth on my easel," Church wrote to art critic Henry Tuckerman in 1867.[19]

Church's method of work required long deliberation, intense concentration, and, usually, rapid execution. He liked to work on a painting in his city and country studios and commented that he did not consider a work to be finished until he had seen it in the light of both. During his first four years on the farm, Church painted *Under Niagara* (1862), *Cotopaxi* (1862), *Chimborazo* (1864), and *The Aurora Borealis* (1865).

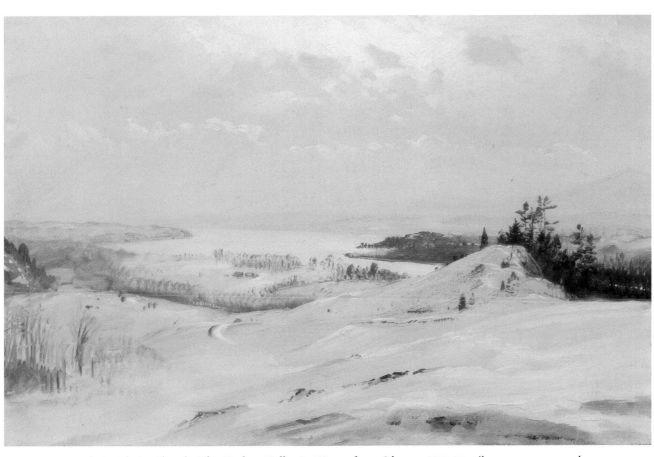

Figure 10. Frederic Edwin Church, *The Hudson Valley in Winter from Olana,* c.1871-72, oil on paper mounted on canvas, 20 1/4 x 13 in.

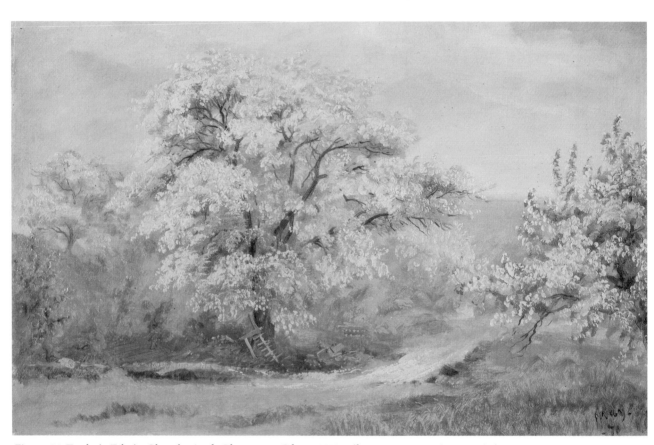

Figure 11. Frederic Edwin Church, *Apple Blossoms at Olana*, 1870, oil on canvas, 11 5/8 x 18 1/4 in.

DESIGNING A LANDSCAPE AND
TRAVELING IN THE MIDDLE EAST

An integral part of Church's early creativity at Olana was the transformation of the property from a strictly agricultural landscape into an ornamental farm. In the mid-nineteenth century, landscape gardening was "the laying-out and improvement of grounds."[1] A book in Church's library—*Landscape Gardening, Parks and Pleasure Grounds*, by the Scottish landscape gardener Charles Smith—outlines the duties of the landscape gardener. Smith recognized the similarity of vision between landscape gardening and landscape painting:

The Landscape-gardener ... is bound to *create* views. ... His business is what is technically called *composition*. This circumstance makes his work parallel to what, we believe, is the highest line of landscape-painting, viz: the formation of pictures by combination of the finest objects which the artist has copied into his sketch-book, or can recall by his memory, or can embody by his imagination.[2]

Church created Olana's landscape as consciously as he created a painting. The farm provided a sublime background; all that was required of Church was the creation of the foreground and middle-ground.[3] A painting of 1864 by Arthur Parton (1842-1914), looking southwest from near the summit of Long Hill, shows a cornfield studded with a few broken trees (figure 12). On this site, Church eventually built the main house. He began to develop Olana's landscape at the apogee of his artistic career and at the height of the popularity of the Romantic style of landscape gardening in America. Church created in his mind's eye the "composition" for Olana's topography and, over thirty years, used his vision to transform the landscape.

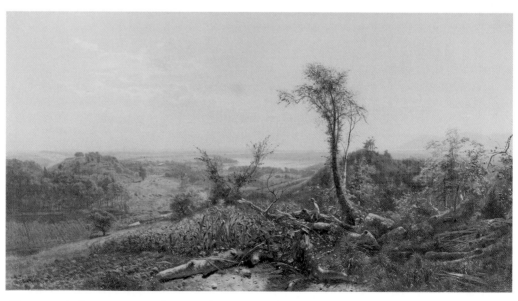

Figure 12. Arthur Parton, *Looking Southwest over Church's Farm from the Sienghenburgh,* 1864, oil on canvas, 19 3/4 x 31 1/8 in.

As a practical Yankee, Church expected a working farm to produce a profit; as a landscape artist, he expected a part of its bounty to be beauty. To achieve the first aim, he hired a farm manager. Orchards and fields of corn, hay and rye joined the flower and vegetable gardens. Church purchased livestock and erected buildings to house them. To achieve his second aim, Church began planting trees in 1860. Smith advised that "trees are the principal means of ornament available to the garden artist. They are, as it were, the colors with which he paints."[4] Years later, Church recalled that "for several seasons after I selected this spot as my home, I thought of hardly anything but planting trees, and had thousands and thousands of them set out on the southern and northern slopes."[5]

He planted maples, birches, hemlocks, chestnuts and oaks singly and in clusters throughout the park on Long Hill. At the same time, his workmen excavated the swampy stream at the foot of Long Hill, and by 1873 they had dug a lake with edges carefully sculpted to echo the shape of the Hudson as it widened to form a lakelike expanse. Within ten years, Church had achieved his first landscape goals, and Cosy Cottage was "embowered by an orchard."[6] He wrote that Isabel "now sits under the apple trees in luxurious contemplation of the beautiful scenes which encircle our little cottage."[7] Church's pencil and oil sketches of Cosy Cottage, the apple orchard in bloom (figure 11), and the views to and from the farm attest to his delight in depicting the landscape he had created and to his success as both a landscape artist and a landscape gardener.

MISFORTUNE, NEW PROPERTY, AND MIDDLE EASTERN TRAVELS

While the Churches were in New York City in March 1865, Herbert and Emma died of diphtheria.[8] Believing a change of scene would help to assuage their grief, the Churches left in late April or early May for Jamaica. They were accompanied by friends, among them artists Fritz Melbye and Horace Robbins. "Poor Mr & Mrs Church," Robbins wrote from Jamaica.

"She is often very sad and speaks to Sarah about her children."[9] Frederic, Robbins explained, "never likes to speak of his feelings" and handled his grief in a different manner: "He works most unremittingly here—seems never to be willing to allow a moment to be unoccupied, I think it does him good to work hard, it makes him forget for part of the day at least his recent great-affliction. He never alludes to it in any-way-whatever—I suppose it must be a great blow to parents to lose all their children at once."[10]

Figure 13. Frederic Edwin Church, *Sunset, Jamaica*, 1865, graphite and white gouache on paper, 10 3/4 x 17 3/4 in., Cooper-Hewitt Museum, Smithsonian Institution/Art Resource, New York.

Even in Jamaica, however, Church often thought of the farm. "When I return to the states," he wrote to farm manager Theodore Cole (the son of Thomas Cole), "I shall hasten up the river to see you all and great good it will do me too—notwithstanding this magnificent scenery (figures 13 and 14). I cannot think of the farm and surrounding friends without great longing."[11] The Churches left Jamaica in the fall of 1865 and spent the winter at the farm. On New Year's Day he wrote, "I am not much interrupted in my studio ... and am accomplishing more than I ever did in my life before."[12] During this period, Church completed *Rainy Season in the Tropics* (1866) and *The After Glow* (1867). Both paintings resonate with the aftershock of the children's deaths.[13] By the spring of 1866, Isabel Church was again pregnant, and Frederic Joseph Church was born on 30 September 1866. Church now had reason to acquire more land and build a suitable home for his family.

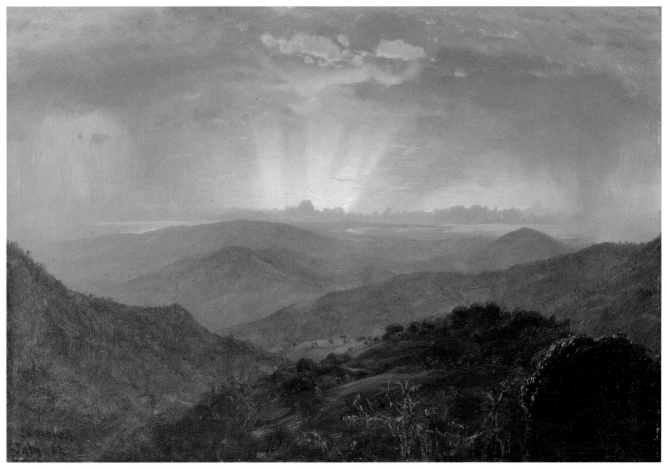

Figure 14. Frederic Edwin Church, *Sunset, Jamaica*, 1865, oil on paper mounted on canvas, 12 1/8 x 18 1/8 in. Church painted this oil sketch in his studio using the pencil sketch of figure 13.

In 1860, Church had paid $80 an acre for Wynson Breezy's farm. Only seven years later he paid more than twice that sum, $194 an acre, for the eighteen-acre wood lot that covered the summit of Long Hill. Church's ambitious landscaping of the property in the 1860s reflected his intention many years before he purchased the land to build a house at the top of the hill above his studio.[14] The importance he attached to the acquisition of this property is evident in his letter to sculptor Erastus Dow Palmer: "I have purchased the wood lot on the top of the hill recently at a high price but I don't regret it. ... I want to secure ... every rood of ground that I shall ever require to make my farm perfect."[15]

To design the house for the summit, Church again engaged Richard Morris Hunt, who envisioned a "French manor" (figure 15). No correspondence between the artist and the architect remains. A pencil and a watercolor sketch for the principal facade and both the original and the revised floor plans do exist, however, and indicate a lengthy process of design and frequent communication between the two men.[16]

In November 1867, Frederic and Isabel Church, accompanied by one-year-old Frederic Joseph and by Isabel's mother, Emma Carnes, departed on a journey to Europe and the Middle East that would last until 1869. In letters to several friends, written in the summer of 1867, Church referred obliquely to his pending trip abroad, which was apparently common knowledge. The reason for his decision to leave off house building and travel abroad may never be known. According to John Davis, Church "spent a great deal of time on research" preparing for the trip.[17] In addition to travel literature, his library contained studies that "attempted to relate the biblical narratives with the actual Palestinian topography," such as Leon de Laborde's *Journey through Arabia and Petraea* (1838), and Oriental romances including Henry Weber's edited *Tales of the East* (1812) and Washington Irving's *The*

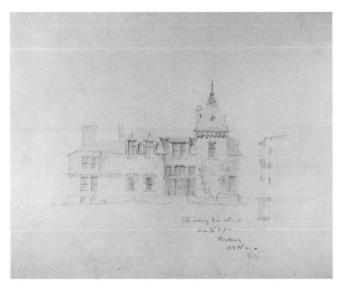

Figure 15. Richard Morris Hunt, *Residence for F. E. Church*, 1867 or 1869, graphite on paper, 15 5/8 x 22 5/16 in.

Alhambra (1859).[18] The Churches were prepared for a journey that united science and romance.

After short stays in London and Paris, the traveling party went to Marseilles, took a steamer to Alexandria, and then journeyed to Beirut, which Church found "beautifully situated at the foot of a high range of mountains which are now snow clad, and the mountain sides are dotted all over with villages, convents, &c. From the houses on the summit of the hill on which the city is built, the views are charming."[19] Church was immediately attracted to the architecture of the dwellings. "I like the houses," he wrote artist Martin Johnson Heade. "They are so solid and capacious and are decidedly effective albeit the carpenter work would amuse our people" (figures 16 and 17).[20]

For the next few months, Isabel, Frederic Joseph and Mrs. Carnes remained in Beirut while Church traveled to Jerusalem and Petra. The desert landscapes and ancient cities moved him profoundly and were the source for a new series of paintings that would record the continuity of human civilization. In South America, Church had sought confirmation of his vision of the earth as an Eden fresh from the hand of God. When Darwin's *On the Origin of Species* challenged this premise in 1859, Church began to study human history as it related to divine plan. He hoped this approach might provide a new scientific basis for the

presence of God's work in human history. As John Davis explains, "Travel through the holy topography [of the Middle East] tended to produce a mingling of space and time, and archaeological data could make human experience seem limitless. Consequently, for the first time, Church became interested in the relics of man."[21]

When Church wrote William H. Osborn of his plans for a house and said, "When you build, build of stone," he was not thinking merely of architectural soundness but of divine timelessness and human continuity.[22] As Davis goes on to say, "Through these stone ruins the entire history of the human race took on [for Church] a kind of simultaneous existence."[23]

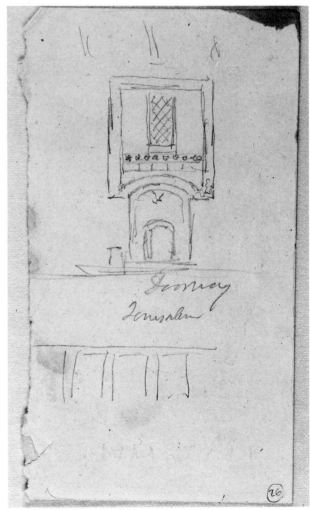

Figure 16. Frederic Edwin Church, *Doorway, Jerusalem*, 1868, graphite on paper, 4 7/8 x 2 7/8 in.

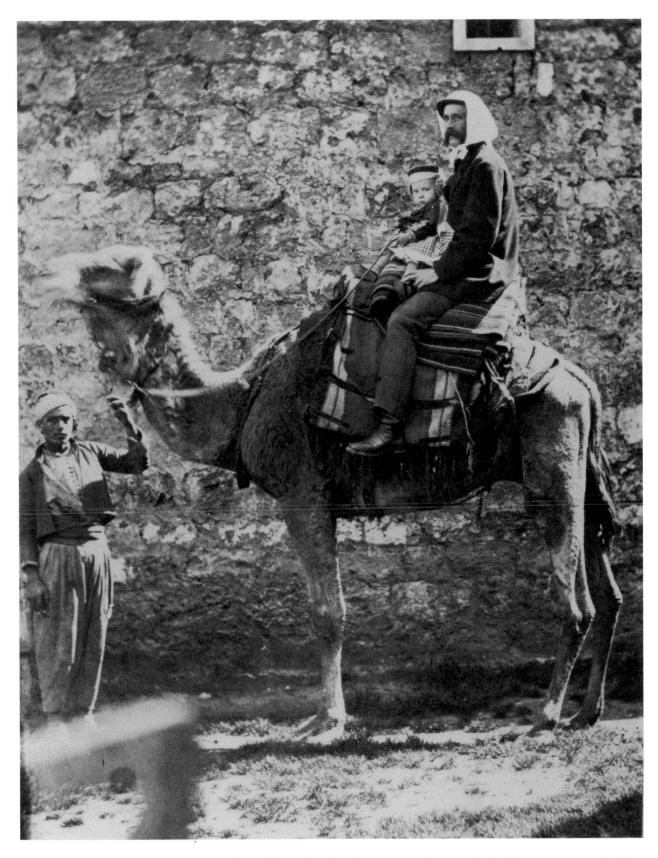

Figure 17. Felix Bonfils [attributed], *Frederic Edwin Church and His Son, Frederic Joseph, in Beirut,* 1868, carte-de-visite, 4 7/8 x 3 3/8 in.

Figure 18. Calvert Vaux, *Study of a House for F. E. Church, Esq., at Hudson, N.Y.*, 1870, graphite on paper, 10 1/4 x 13 3/4 in., inscribed l. r. "By architect/2nd sketch."

DESIGNING A HOME

The Middle Eastern journey gave Church a changed intellectual sensibility that radically affected his image of what a house should be. "The Dwellings [of Beirut] are often quite grand," he wrote Palmer. "They have a large room called the court in the center often 30 x 50 feet or larger—and perhaps 30 feet high and smaller rooms on each side. ... I have got new and excellent ideas about house building since I came abroad."[1] In addition to the central courtyard, he decided that his house should have thick, fortresslike walls and that the interior should reflect the ornamental intricacy that he and Isabel saw in many Moorish homes. In sum, the house would be "Persian, adapted to the Occident."[2] As a seventh-generation New Englander, Church would build a "permanent" home where the next several generations of his family would dwell.

Years later, Lockwood de Forest (1850-1932), Church's former pupil, reminisced that Church "had decided that he could learn more from Oriental architecture [about] how to plan a house than from any other [architecture] as he had been deeply impressed with it when he spent the winter of 1868 in Beyrout and Damascus."[3] A letter written by the couple's daughter to Church's biographer affirms Isabel's role in the design of the house: "Could my little Mother's ... influence on his building this house too be brought in? ... I have not mentioned this to Papa—but he has often spoken of how her taste in the house is shown from top to bottom—and her advise [sic] was asked about it all."[4]

The Churches spent the winter of 1868-1869 in Rome, where another son, Theodore Winthrop, was born on 22 February 1869. Church's letters and actions reflect his continued longing for "our home on the Hudson" and his growing preoccupation with the new house: "sometimes the desire to build attacks a man like a fever—and at it he rushes."[5] Church revealed his enthusiasm for building in successive letters to Osborn, who was then building houses on his farm at Garrison, New York, and on Park Avenue. "Don't settle any plans about building a house until I return," Church wrote him. "I am conceited enough to wish to thrust my finger into that pie and offer my opinions on domestic architecture."[6] Church then went on to criticize Osborn's current architect, thus indicating his opinion of the architect's role in house building: "I don't think him good at contriving nor good at effect—both pretty important considerations in architecture. ... A Clever *young* architect who has been trained in a good school will be the best man to give shape to the emanations from our three heads and we will place first Mrs Osborn's head. A young architect is more painstaking and more tractable than an old and popular one."[7]

The Church family returned to New York City on 28 June 1869, and Church journeyed to the farm ahead of Isabel to prepare for her and the babies. Church wrote Palmer of his determination to build a new dwelling: "I long for a new house ... I expect to build next season."[8] He may have turned again to Richard Morris Hunt for new house plans, since two elevation drawings and a plan for the chamber floor exist, all drawn by Hunt in the Moorish style.[9]

Sometime between June 1869, and May 1870, Church changed architects. Perhaps Hunt's designs did not match the "emanations" from Church's head. To replace him, Church chose Calvert Vaux (1824-1895), whom he had known since at least the middle 1850s. Born in England, Vaux worked for Andrew Jackson Downing (1815-1852) and married Mary Swan McEntee, the sister of Church's former pupil and friend Jervis McEntee (1828-1891). Like Church and Hunt, Vaux was a member of the Century Club.[10] In his book, *Villas and Cottages*, Vaux wrote that "in all times of great art, there has always been a close connection between Architecture, Sculpture, and Painting. ... Architecture derives its greatest glory from such association."[11] Vaux agreed with Church's passion for natural beauty, and his theory of architecture suited Church's aesthetics—his standard of "contriving and

effects," about which Church had written Osborn. "As [architecture] seeks to please the eye," Vaux wrote, "its forms and colors should be carefully designed in accordance with the laws of the eye, or it will be a failure."[12] His book also shows that he was familiar with Middle Eastern styles, whose "magical effects" he praised.[13] Most important, Vaux was accustomed to creating and often modifying his designs on the basis of clients' suggestions.[14]

In his letters for the next two years, Church often discussed his house plans. He was in frequent communication with Vaux, probably receiving drawings from him during the winter of 1869-1870. Church also began house sketches of his own. On 13 May 1870, he wrote Palmer, "I want to show you my plans and have your critical judgement."[15] An elevation Vaux prepared for the house is dated May 28, 1870 (figure 18); other contemporaneous drawings that he provided include a staircase elevation and original and revised floor plans. The latter, no doubt

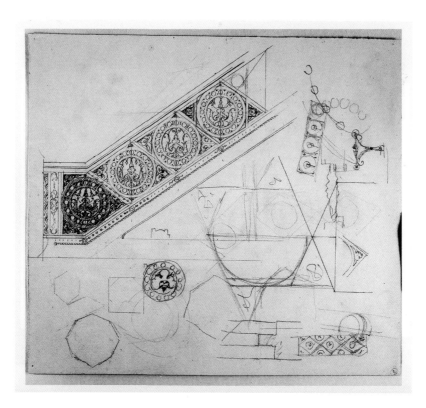

Figure 19. Frederic Edwin Church, *Design for Balustrade for the Main Staircase at Olana*, September 1873, graphite and ink on paper, 10 3/8 x 11 7/8 in.

drawn to Church's directions, must have met his requirements well, for they were amended only to include a more generous service wing. One element of Vaux's floor plan—the recessed veranda, or ombra, with the court hall behind—is similar to Hunt's original floor plan, and therefore can be attributed to Church. In both floor plans, the ombra and court hall were oriented to the panoramic view of the Hudson and Catskills.

In Church's revision of Vaux's elevations, the building's overall height, the configuration of the towers, and the decorative details are by Church (figures 19-24); only Vaux's massing remains. Years later, in an undated handwritten record of his most important commissions, Vaux wrote that he "was consulting architect/for Mr. F. E. Church/the artist/House Hudson River."[16] Clearly, Church initiated the design, though he would not have hired Vaux if the artist had intended to be the sole architect. Church's sketches and correspondence show his control of the details and of the whole. Vaux had the

contractual responsibility to provide a sound structural foundation and frame. More than 500 drawings and 250 stencils record Church's pursuit of the "perfect" house. Church designed the building in the same way he created a work of art (figures 19 and 20). He began with preliminary pencil sketches, which he followed with color drawings that then guided house construction (figures 21-24).

Church's correspondence suggests that the relationship between the two men was not without difficulty. "I have been much delayed by being separated from my Architect although he has been up several times to see me," he wrote Palmer in July 1870.[17] While there is no direct evidence of conflict, Vaux's aesthetic views, if ever different from Church's, must have given way to the views of the artist and owner. On the other hand, Church's vision of the house had to stand on Vaux's technical competence. Because Vaux was not regularly on the building site, one can imagine Church encountered frequent construction difficulties, as

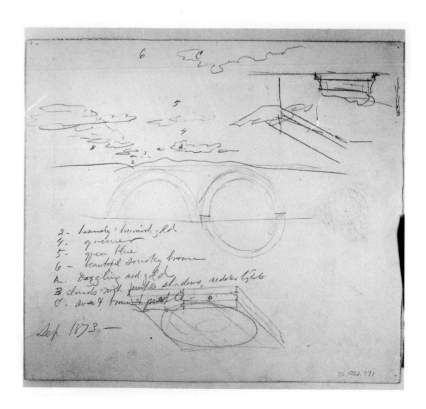

Figure 20. Frederic Edwin Church, *Sunset at Olana*, September 1873, graphite and ink on paper, 10 3/8 x 11 7/8 in. This sketch is on the reverse of figure 19 and suggests that Church may have interrupted his balustrade design to sketch a sunset. Almost two years earlier, on October 24, 1870, Church had written Martin Johnson Heade, "I have actually been drawn away from my usual steady devotion to the new house to sketch some of the fine things hung in the sky." (Letter to M. J. Heade, 24 October 1870, Archive of American Art, Smithsonian Institution, Washington, D.C.)

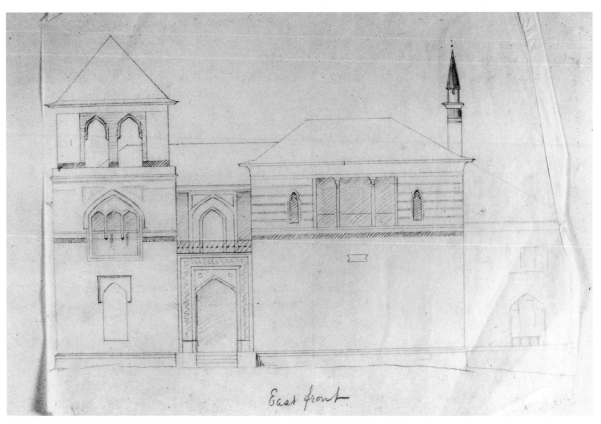

Figure 21. Frederic Edwin Church, *East Facade, Olana*, c. 1870, medium and dimensions unknown, from a photograph. Figs. 21-24 illustrate the final stage in the design of the major facades.

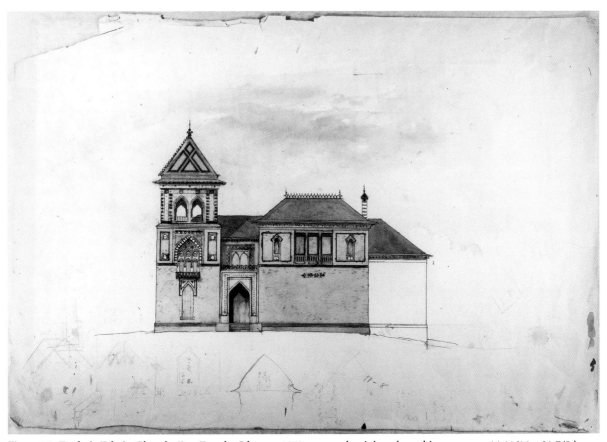

Figure 22. Frederic Edwin Church, *East Facade, Olana*, c. 1870, watercolor, ink and graphite on paper, 14 11/16 x 21 7/8 in.

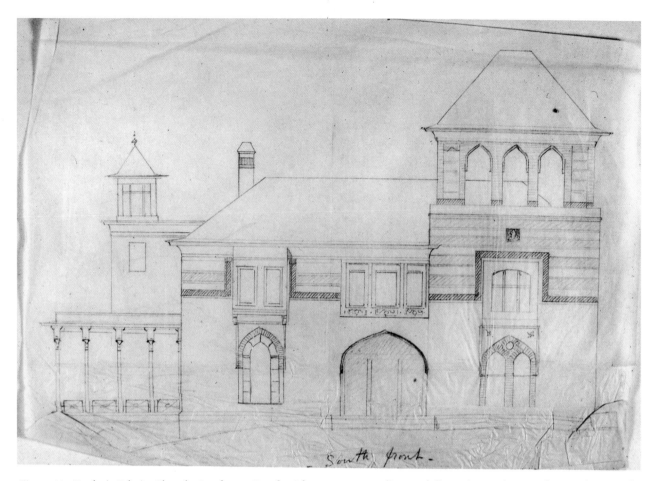

Figure 23. Frederic Edwin Church, *Southwest Facade, Olana,* c. 1870, medium and dimensions unknown, from a photograph.

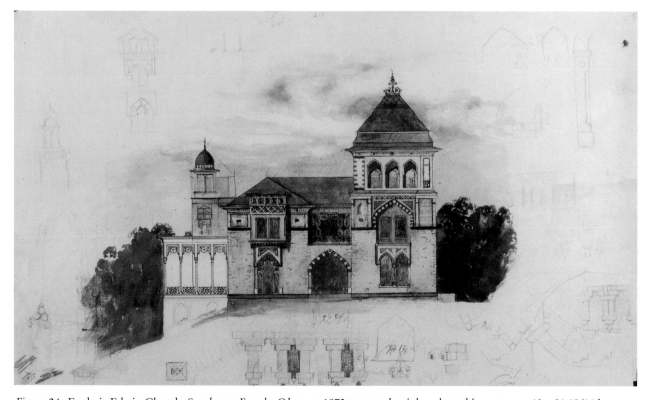

Figure 24. Frederic Edwin Church, *Southwest Facade, Olana,* c. 1870, watercolor, ink and graphite on paper, 13 x 21 15/16 in.

Church suggested in a letter to artist John Ferguson Weir (1841-1926):

I hope to be in New York in a week or so—but a Feudal Castle which I am building—under the modest name of a dwelling house—absorbs all my time and attention. I am obliged to watch it so closely—for having undertaken to get my architecture from Persia where I have never been—nor any of my friends either—I am obliged to imagine Persian architecture—then embody it on paper and explain it to a lot of mechanics whose ideal of architecture is wrapped up in felicitous recollections of a successful brick school house or meeting house or jail. Still—I enjoy this being afloat on a vast ocean paddling along in the dreamy belief that I shall reach the desired port in due time.[18]

As in Church's paintings, the artist's creative imagination was the source for many of the decorative elements in the house. At the same time, however, the ornamental motifs at Olana were grounded in his

Figure 25. Jules Bourgoin, "Porte de L'Eglise de St. Jacques des Armeniens, à Jerusalem, Plate 27," *Les Arts Arabes,* 1868, ink on paper, 17 1/2 x 12 3/8 in.

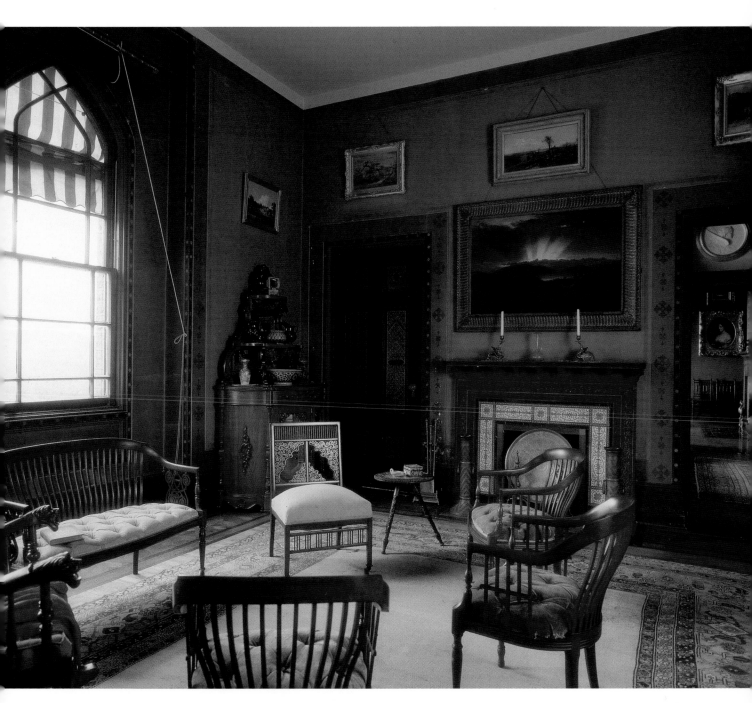

Figure 26. East Parlor, Olana, 1997 © Kurt Dolnier. The stenciled doors of the east parlor make use of Church's adaptation of the design in figure 25. The large painting above the fireplace mantle is Church's *The After Glow* (1867).

Figure 27. Frederic Edwin Church, *Sketch of Bay and Tower, Southwest Facade, and Moulding Profiles, Olana*, c. 1870-72, graphite on paper, 10 1/8 x 7 1/2 in. Figs. 27-31 illustrate several stages of the evolution of Church's design for the bay and cornice on Olana's southwest facade. This developmental sequence exemplifies the way in which Church created a work of art.

Figure 28. Frederic Edwin Church, *Four Sketches for Attic Window and Cornice, Bay, Southwest Facade, Olana*, c. 1870-72, graphite on paper, 10 1/8 x 7 1/2 in.

Figure 29. Frederic Edwin Church, *Bay and Cornice, Southwest Facade, Olana,* c. 1870-72, oil and graphite on paper, 9 3/8 x 7 in.

Figure 30. Frederic Edwin Church, *Detail of Attic Window and Cornice, Bay, Southwest Facade, Olana,* c. 1870-72, oil and graphite on paper, 6 1/2 x 9 1/4 in.

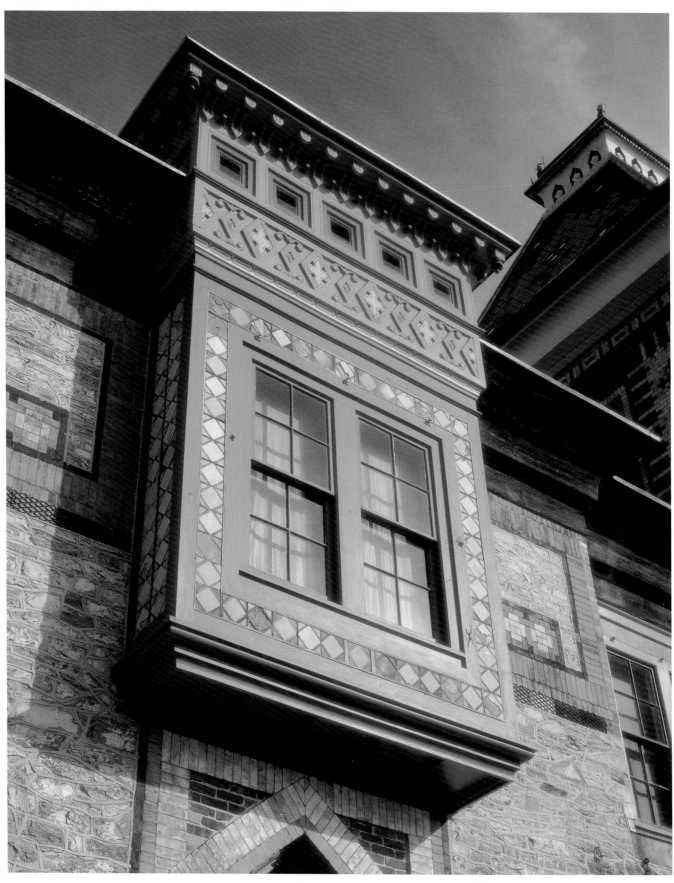

Figure 31. Bay, Southwest Facade, Olana, 2000 © Kurt Dolnier.

recollections of Middle Eastern residences and adapted from books on Persian architecture that he purchased for his library. His use of Middle Eastern pattern books illustrates the spontaneous evolution of the house design. Two books on Persian architecture provided an important basis for various house designs. In Pascal Coste's *Monuments Modernes de la Perse* (1867), Church found designs for the piazza columns, the water tower, and the stencils for the court hall arches and their spandrels. Jules Bourgoin's *Les Arts Arabes* (1868) inspired the east window and its decorative wood screen and the stencil design on the interior doors (figures 25 and 26).[19]

Church's diligent labors on the house and his thorough study of Persian architecture are confirmed by Lockwood de Forest, who later reminisced that from 1870 on "I was a great deal with Mr. Church for nearly 10 years. I staid [sic] with him painting in his studio and going over his plans for the house he was building, and studying all the books on Persian, and Oriental Architecture in the evenings."[20]

By November 1870, Church saw his "way through clearly so far as the design and construction of the building is concerned."[21] The imaginative use of memories and pattern books allowed Church to "contrive effects" that pleased the eye in architecture. He prepared hundreds of architectural sketches. Many sheets contain twenty-five or more separate drawings of such architectural elements as finials, molding profiles, staircase balustrades, brick and stone patterns, and geometric floral designs for the stencils that would cover the interior walls and the exterior cornices. Most of these elements were never used in the final design; instead, they record Church's visual experimentation with his pencil (figures 27-31).

With the births of two more children—Louis Palmer in April 1870 and the couple's only daughter, Isabel Charlotte, in July of the next year—Church no doubt felt that he had made a wise decision to build a larger house. During the summer of 1871, the stone walls of the house rose to their full height but were not yet roofed. Church showed the unfinished structure to a visiting journalist, who wrote that "the moustache of our guidebook [i.e., Church] became more and more animated, and fairly kindled in describing the liberal ground proportions of a mansion whose principal 'up stairs' the height itself has furnished."[22]

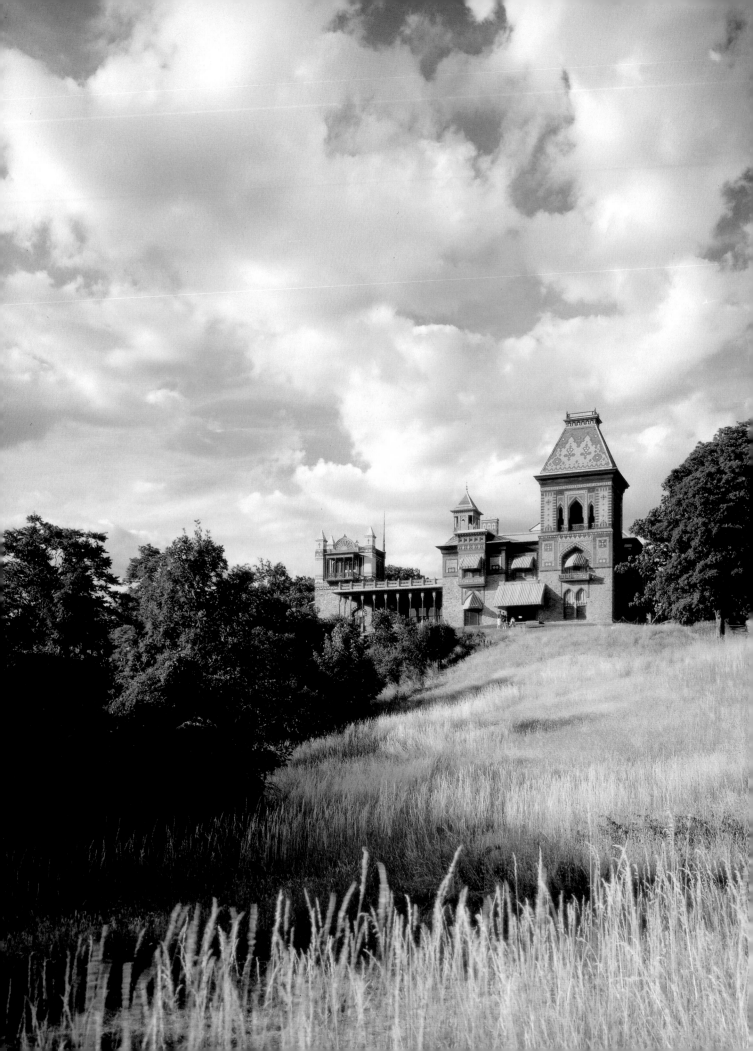

CHAPTER 4

FINISHING THE HOUSE

By late 1872, much of the house was complete, and the family moved into the second story as Church began to decorate the first-floor rooms. In October 1872, the artist's cousin Henry Mack visited the house and thought it "a unique structure" (figure 32).[1] He saw a massive, cubelike, two-story structure with two towers projecting above the roofs. The thick stone walls of the first story were "of a dark brown color"; the material from which they were built had been quarried from the house site.[2] The second-story facades were more complex, with red, yellow, and black bricks forming geometric mosaic patterns in the stone. Painted in geometric floral designs, the cornices of the second-story were "decorated in beautiful colors," reminding one of an Islamic garden.[3]

The exterior massing reflected the interior divisions. Double-height entries pierced the centers of the east and the south facades. A double-height stairway window was centered on the north facade. Out of sight because of the sheer drop of the ridge, the west facade was unelaborated except for a polychromed piazza, which allowed the family an uninterrupted view of the Catskill sunsets. On the east, south, and north facades, the centered doors and windows were given additional emphasis through second-story recesses, projections, changed rooflines, or elaboration with decorative tiles.

Simple and balanced, the floor plan of the first story is a Greek cross with rooms filling the spaces between its arms (figure 33). The court hall is the cross itself, around which are the major spaces of the house—east parlor, sitting room, kitchen wing, and dining/picture gallery. The four arms of the court hall end in four smaller spaces that serve as vestibule,

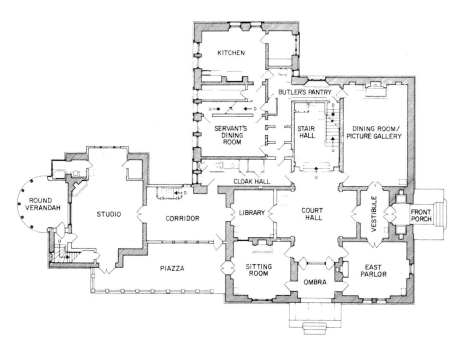

Figure 33. Floor plan, Olana, with Studio Wing Addition.

Figure 32. Southwest Facade, Olana, 1998 © Esto Photographics.

ombra, library, and stairhall. As the court hall organizes the house spatially, it also organizes the house visually. The court hall's centered doors and windows frame the vistas beyond. Originally, Church planned the court hall to be a double-height room, illuminated by a skylight and visually anticipated by the centered double heights of the front door, ombra window, library doors, and stairhall window. The family needed additional room upstairs, however, so this higher space, although framed in by the carpenters, was floored over.[4]

STENCILING THE INTERIOR

In June 1873, Jervis McEntee noted in his diary that the family continued to live in the second story as the carpenters were "at work down below."[5] Completion of the woodwork and painted decoration of the first floor required at least four years.[6] The simple floor plan is overlaid and enriched by the elaborate painted and stenciled decorations that have a subtle but cohesive organization. Although the initial impression is a random profusion of color overwhelming the eye, Church, in fact, left no aspect of the decoration to chance. Mixing pigments on his palette, he prepared color swatches for the walls and ceilings of each room. In the wet paint, using the butt of his brush, he inscribed the name of the room and the pigments employed to obtain the color. On one swatch, he set out the final colors for every room, perhaps for Isabel and himself to evaluate (figure 34).

Church designed the stencils in the same manner as he did the house, making a profusion of pencil sketches (figure 35), then color renderings of those he and Isabel preferred, then stencils for execution in place by his workmen. The interior

stencils are not the all-over wall patterns so often seen in the work of Associated Artists and Viollet-le-Duc. Rather, the patterns are used as borders that delineate doorways, window frames, base boards and, occasionally, a frieze. Church used copper and zinc for 'gold' and tin for 'silver', both for applying the elaborate stencils on the doors and for outlining and emphasizing the wall stencils (figures 36 and 37).[7] Most important, the metallic quality of these stencils added reflective light.

The key to understanding the colors and stencils is found in the court hall, which forms the spatial, visual, and artistic center of the house. Grace King, a guest at Olana in the 1880s, found "the great pillars [of the court hall] a mass of color,"[8] but closer exami-

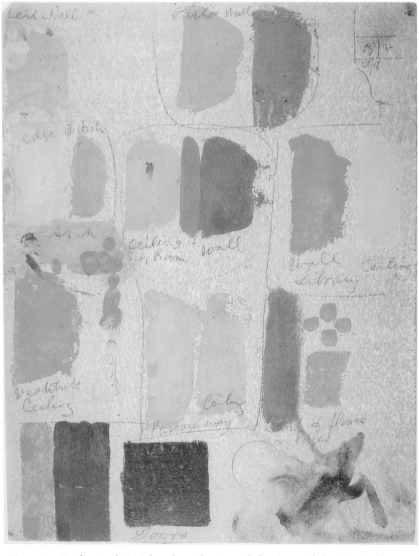

Figure 34. Frederic Edwin Church, *Color Swatch for Some of the Principal Rooms of the First Story, Olana,* c. 1872-74, oil and graphite on paper, 13 7/8 x 10 7/8 in.

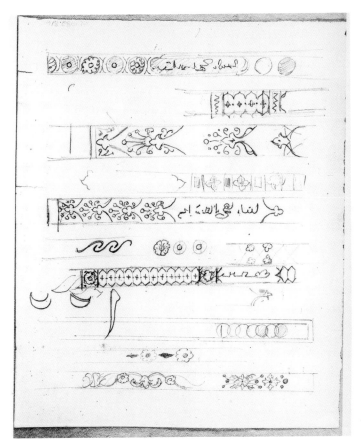

Figure 35. Frederic Edwin Church, *Sketches for Stencil Borders, Olana,* c. 1872-74, graphite on paper, 8 5/8 x 6 7/8 in.

Figure 37. Frederic Edwin Church, *Stencil Cut Out for Central Floral Motif, Double-leaf Doors, Olana,* 1873 or 1890, aluminum powder on paper, 9 7/8 x 6 1/2 in.

Figure 36. Frederic Edwin Church, *Stencil Cut Out for Border, Double-leaf Doors, Olana,* c. 1873, bronze powder on paper, 10 11/16 x 6 1/2 in.

Figure 38. (left) Frederic Edwin Church, *Sketch for Stencil Border, Court Hall, Olana,* 1870-74, graphite on paper, 19 1/4 x 9 3/4 in.

Figure 39. (right) Frederic Edwin Church, *Stenciled and Painted Mock-up, Court Hall Borders, Olana,* 1872-74, oil on paper, 23 3/4 x 5 3/4 in.

nation reveals an intricate interrelationship of hues and tones. The colors of the court hall's walls and stencils are yellow, purple, red, coral, salmon, gold-brown, and green (figures 38 and 39). In various combinations, these colors radiate to the adjoining rooms and even to the exterior. The salmon color found at the edge of the broad Islamic arches in the court hall, for example, reappears in the sitting room—in the window and door embrasures, in the marble fireplace front, and in *El Khasné Petra* (figure 51), Church's painting of 1874 that is the visual focus of the room,

which was completed in 1875. In fact, the colors in *El Khasné Petra* are all repeated in the room, which becomes a shadow box for the painting. The salmon color reappears on the exterior cornices and on the column capitals of the piazza. Another example of color interrelationship is in the coral edge of a flower petal on the walls of the court hall. That color reappears in another petal in the vestibule and in the arched vault of the entrance recess. Like the salmon, this color is also found on the cornices and on the piazza capitals (figures 40-43).

Figure 40. Frederic Edwin Church, *Sketch for Stenciled Decoration, Dining Room Cornice, Olana*, 1870-72, watercolor and graphite on paper, 12 x 9 1/8 in. Figures 40-43 illustrate the stages that Church moved through in designing the exterior cornice for Olana's dining room. He used a similar process for designing the stencils for Olana's other four cornices.

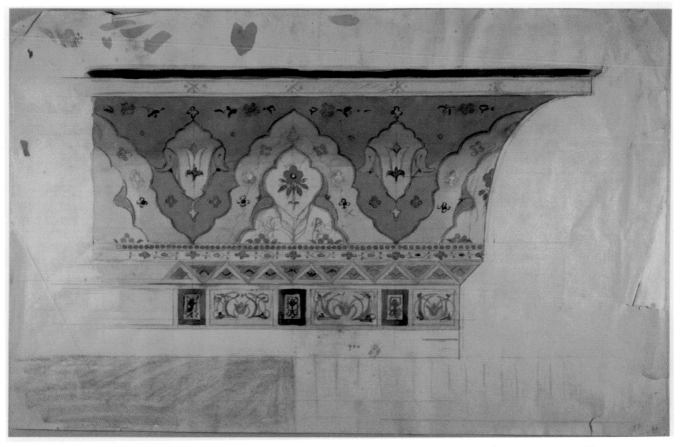

Figure 41. Frederic Edwin Church, *Sketch for Stenciled Decoration, Dining Room Cornice, Olana*, 1870-72, graphite on paper, 7 x 9 1/8 in.

Figure 42. Frederic Edwin Church, *Sketch for Stenciled Decoration, Dining Room Cornice, Olana*, 1870-72, oil and graphite on paper, 6 5/8 x 17 7/8 in.

In Damascus, the Churches had visited a house that may have provided one model for the poly-chromed and metallic stencils used at Olana. In her diary, Isabel wrote:

> Walls & ceiling [were] highly and gor-geously decorated, and mirrors everywhere, amid the decorations, little bits of mirrors— doors & all the woodwork—inlaid with ivory & mother of pearl—At night by candle light, the effect must be quite splendid—One is reminded of Arabian nights tales.[9]

Certainly, Olana's effect on some visitors was a sense of Middle Eastern fantasy. As one visiting journalist concluded in 1889, "One feels as if transported into the Orient when surrounded by so much Eastern magnificence."[10]

Figure 43. Frederic Edwin Church, *Stencil Cut Out for Ornament, Dining Room Cornice, Olana*, 1872, oil and graphite on paper, 14 5/8 x 15 3/8 in.

Church brought back from abroad not simply the idea for a Moorish house. The trip inspired in him the desire and confidence to create the house and its interior himself. Ten years earlier, Richard Morris Hunt had drawn the plans for Cosy Cottage, and factories and relatives had provided the furnishings readymade.[11] Now, Church himself was the designer and decorator (figures 44-46).[12]

In furnishing the house, one of Church's first aims was to create a repository for the objects of civilization. "The whole house," wrote a journalist, "is a museum of fine arts, rich in bronzes, paintings, sculptures, and antique and artistic specimens from all over the world."[13] The rooms were filled with exotic objects: painted Kashmiri tables and chairs, Shaker rockers, rococo revival furniture inherited from his father, and furniture built to Church's own designs were intermingled with Persian and Syrian metalware, Mexican religious statuary, mounted South American birds and butterflies, marble and bronze statuary by Erastus Dow Palmer, and Turkish rugs. Church conceived this collection and began to acquire it while he was in the Middle East. In Damascus, the Churches called on the notorious Lady Jane Digby El Mezrab, an Englishwoman married to a Moslem sheik.[14] They found her parlor "furnished semi oriental, semi European—forming a very agreeable and pretty combination."[15] Before leaving the Middle East, they purchased "rugs—amour—stuffs—curiosities...old clothes (Turkish) stones from a house in Damascus, Arab spears—beads from Jerusalem—stones from Petra and 10,000 other things."[16] These objects were packed in at least fifteen crates and shipped back to the United States.[17]

Most of the objects that comprise the exotic diversity of the house have little intrinsic value. Rather,

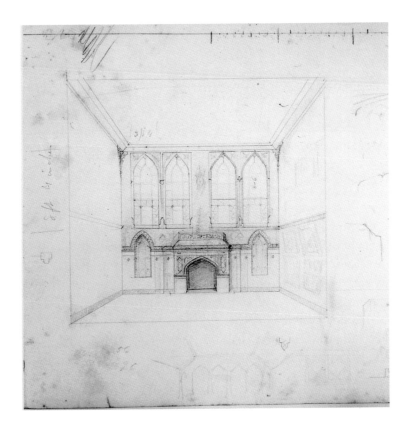

Figure 44. Frederic Edwin Church, *Perspective Sketch of Dining Room/Picture Gallery, Olana,* 1870-74, graphite on paper, 11 7/8 x 17 in. Note the paintings on the side wall and the armorial trophy over the fireplace. Eventually, Church placed this trophy at the stair landing.

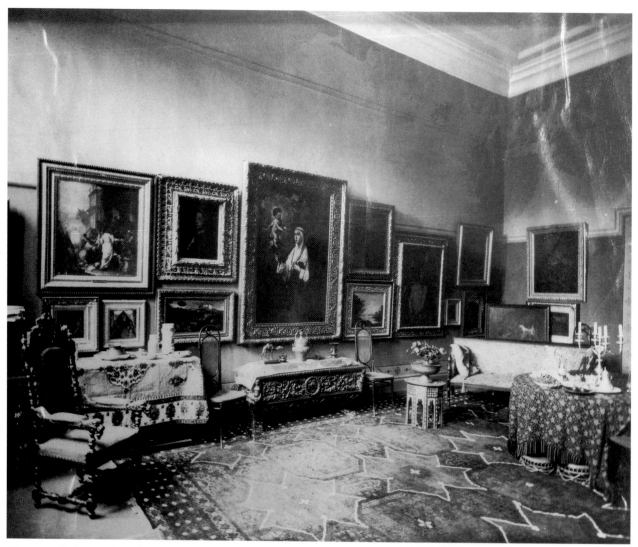

Figure 45. Robert and Emily de Forest, *Dining Room Picture Gallery, Olana*, October 11, 1884, albumen print, 6 7/16 x 8 3/16 in.

Church selected objects in part for their visual and associative effects. Like the Middle Eastern architecture that inspired the design of the house, the artifacts that furnish the house have an iconographical significance; they were physical and symbolic expressions of ancient cultures and religions (figures 47 and 48). A gilded Buddha, a polychromed madonna, ancient armor, fragments of the Parthenon, striated stones from Petra, pre-Columbian artifacts—these objects, for Church, represented the survival and distillation of civilization brought to a new Eden—his farm in the Hudson Valley (figure 49).[18]

But for what purpose? Church wished to create a home for his family. Nineteenth-century mores dictated that parents provide a home in which children could be reared to be the best possible human beings. At Olana, Frederic and Isabel Church could nurture a "new Adam," but with the advantage of all past civilizations as mentor.[19] After trying several other names, the Churches had chosen the name Olana by 1880. Gerald Carr's research shows that the name is a variation on *Olane*, a fortress-treasure house in ancient Persia. The Churches had never recovered from the loss of their babies in 1865, and the house was a fortress built to protect the fragile new family. As Carr concludes, Olana's treasure was not merely the objects, but the children.[20]

Church made this intention clear in 1875, four years before the property was named, when he hung his painting of *El Khasné Petra* (figure 51) in the sitting

Figure 46. Dining Room, Olana, 1997 © Kurt Dolnier.

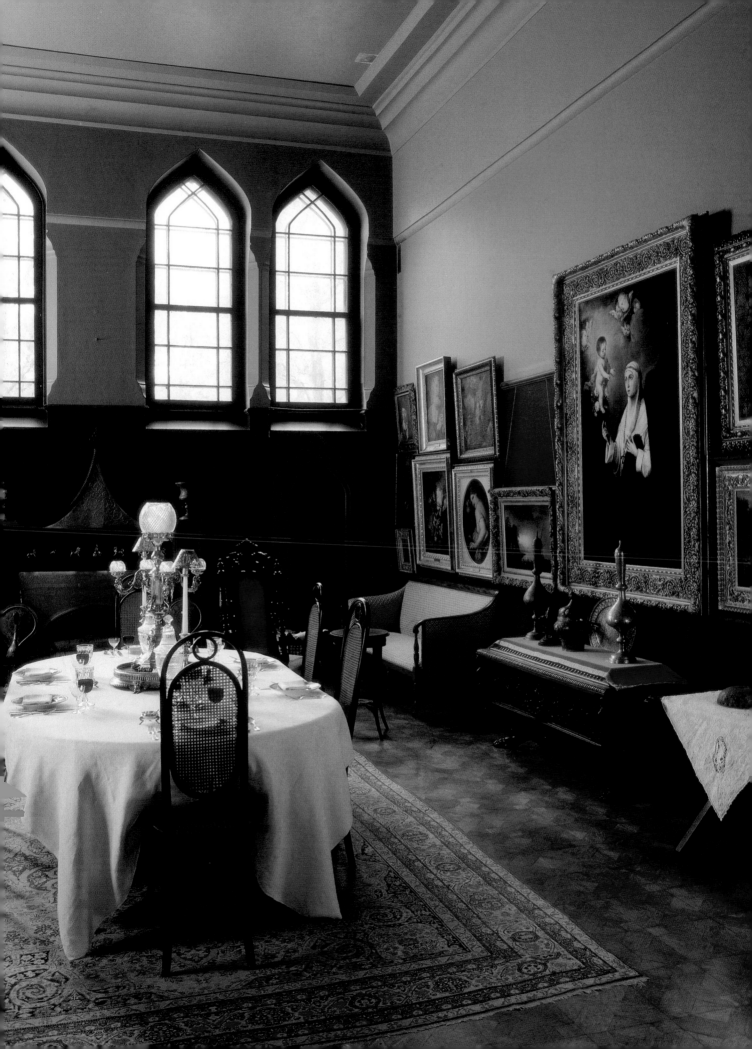

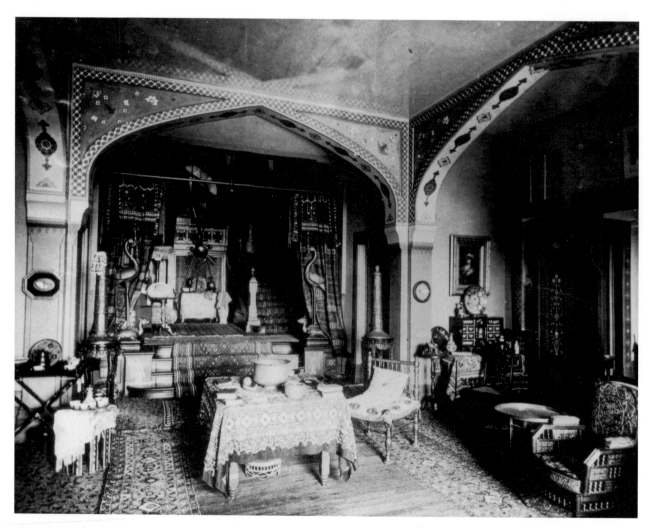

Figure 47. Robert and Emily de Forest, *Court Hall, Olana*, October 11, 1884, albumen print, 6 1/4 x 8 3/8 in.

Figure 48. Unidentified photographer, *Stair Hall, Olana*, c. 1891, albumen print, 8 7/16 x 6 1/8 in.

(Next page) *Figure 49. Court Hall, Olana*, 1997 © Kurt Dolnier.

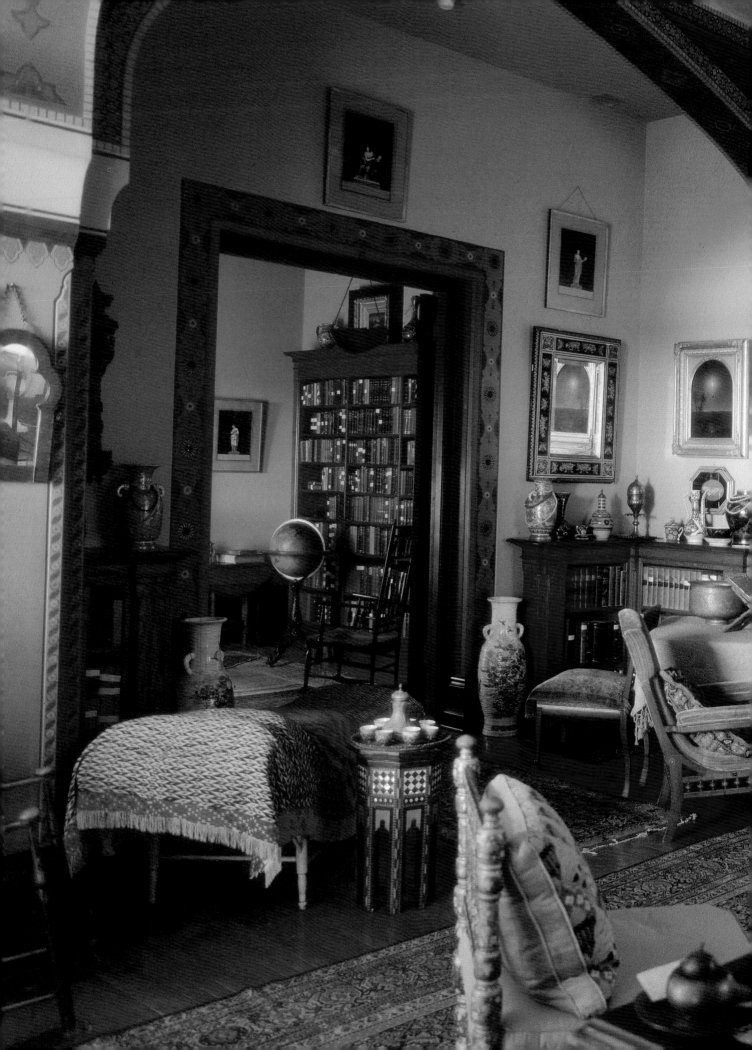

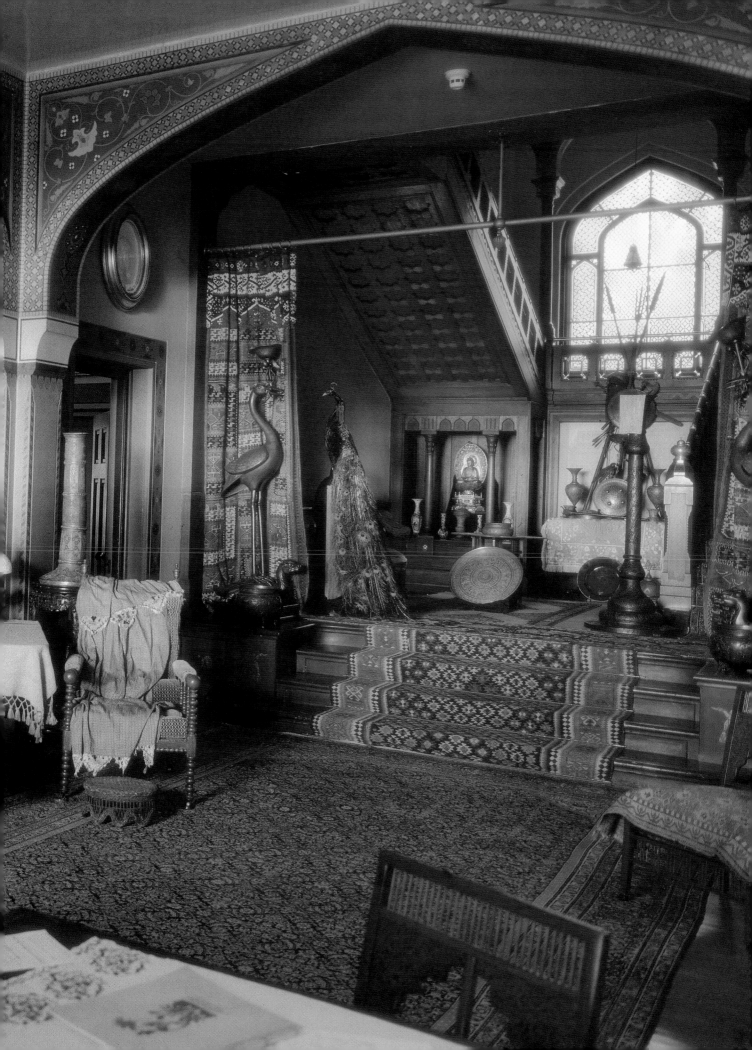

room, the principal gathering place for the family (figure 50). The painting depicted an ancient treasury house carved from stone. For Church, this place was so rich with associations of civilization that upon first seeing it he recorded in his diary that the temple appeared illuminated "as if by its own internal light."[21] *El Khasné Petra* was the civilized equivalent of the spiritual peace and hope he had found in the wild nature depicted in *Twilight in the Wilderness*, the painting that he interrupted to travel up river on the eve of his marriage to purchase the farm. The home that Church created at Olana needed the corrective of past civilizations.

In a letter of 1877 written to his close friend Amelia Edwards, Church succinctly described the home he had created. He emphasized the harmony of interior and exterior elements and the visual relationship of the house to the larger landscape. Most significantly, he declared his responsibility for the house design:

I designed the house myself. It is Persian in style adapted to the climate and the requirements of modern life. The interior decorations and fittings are all in harmony with the external architecture. It stands at an elevation of 600 feet above the Hudson River and commands beautiful views of sky, mountains, rolling and savannah country, villages, forest and clearings. The noble River expands to a width of over two miles forming a lakelike sheet of water which is always dotted with steamers and other craft.[22]

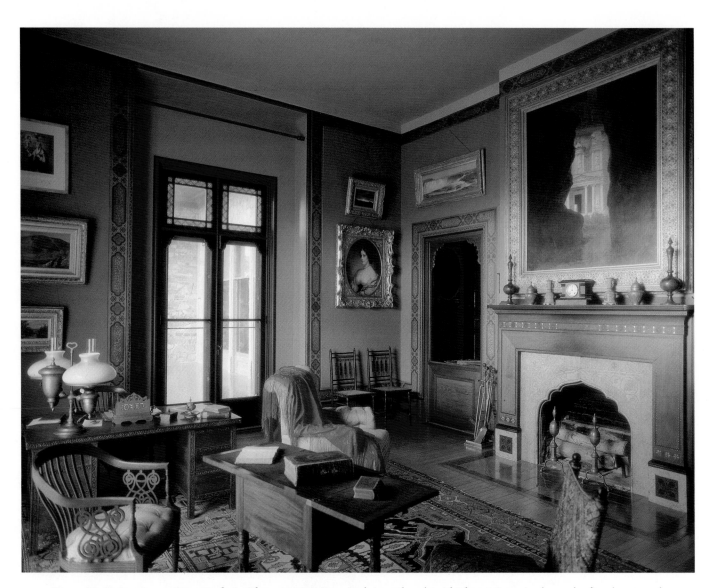

Figure 50. Sitting Room (West Parlor), Olana, 1997 © Kurt Dolnier. Church's *El Khasné Petra* is above the fireplace mantle; immediately left is a small oil sketch by Church for *Niagara*.

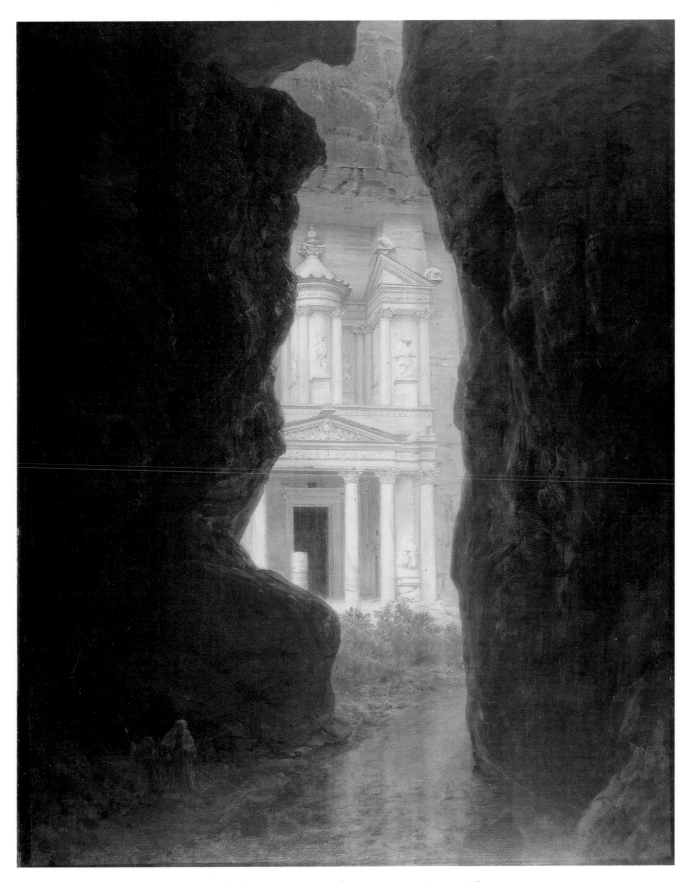

Figure 51. Frederic Edwin Church, *El Khasné Petra*, 1874, oil on canvas, 60 1/2 x 50 1/4 in.

Figure 52. Unidentified photographer [possibly Louis Church], *The House and Park from across the Lake, Olana,* c. 1892, albumen print, 4 3/4 x 7 1/16 in.

ADDING A STUDIO AND COMPLETING THE LANDSCAPE

In 1869, Church experienced recurrent pain that was the beginning of a crippling rheumatism, possibly caused by the materials of his art.[1] At the same time, the public's taste for Church and the works of the Hudson River School waned as the work of the Barbizon painters grew in popularity. Over time, Church painted less and, according to Isabel, was often despondent.[2]

An important solace was his continuing work on the house and grounds. As he wrote to Heade in 1885, "I have been and am tied down at home—I undertake to make thorough repairs of my House—nothing of importance in that way having been done since it was built 13 years ago."[3] For the next six years, beginning in 1885, his improvements created the appearance of the house we know today. Among these embellishments were parquet flooring in several rooms, carved Indian fireplace fronts ordered from Lockwood de Forest, and stencils for the pillared screen on the stair landing.

Church's sister Elizabeth, the only surviving member of his immediate family, died in 1886. He inherited the Hartford family house and a large number of his own works that his parents had proudly collected, including *Christian on the Borders of the "Valley of the Shadow of Death," Pilgrim's Progress* (1847), *Autumn* (1856), and *The After Glow* (1867). These paintings greatly changed both the appearance and atmosphere of the interior, bringing Church's public art into his private home. Except *El Khasné Petra*, only paintings and copies of the old masters had hung in the house

before 1886.[4] The presence of his own paintings, as well as the acquisition of two works by Cole—*A Solitary Lake in New Hampshire* (1830) and *View of the Protestant Burying Ground, Rome* (c. 1834)—continually reminded Church of his teacher and the career that had brought him to this place that was "the Center of the World."[5]

In 1888, Church's renewed interest in the house culminated in the construction of a studio wing that also included a connecting corridor, an observatory, a bedroom and storage space. In June, Church wrote to artist Charles DeWolf Brownell: "I am indeed busy night and day with my plans and as I am architect and make the drawings you can readily believe that I have little spare time. ... I wonder if I shall work as hard in the new Studio as I do in erecting it."[6] His degenerative rheumatism forced Church to change his design procedure somewhat. He made fewer drawings and thus had "to explain every little detail. It is not a little difficult I find to keep the work going economically when none of the men really know what is coming next."[7] In 1889, Church closed the New York City studio he had rented for thirty years and shipped its contents to Olana.[8]

The studio wing required three years to build and cost approximately $30,000. For Church, who recollected with such happiness the building of the original house, the studio wing's design and construction were an end in themselves and energized him to paint (figures 53 and 54). Although Church worked in the new studio during the late summer of 1890, not until April 1891 did he describe the space in full use. As he wrote

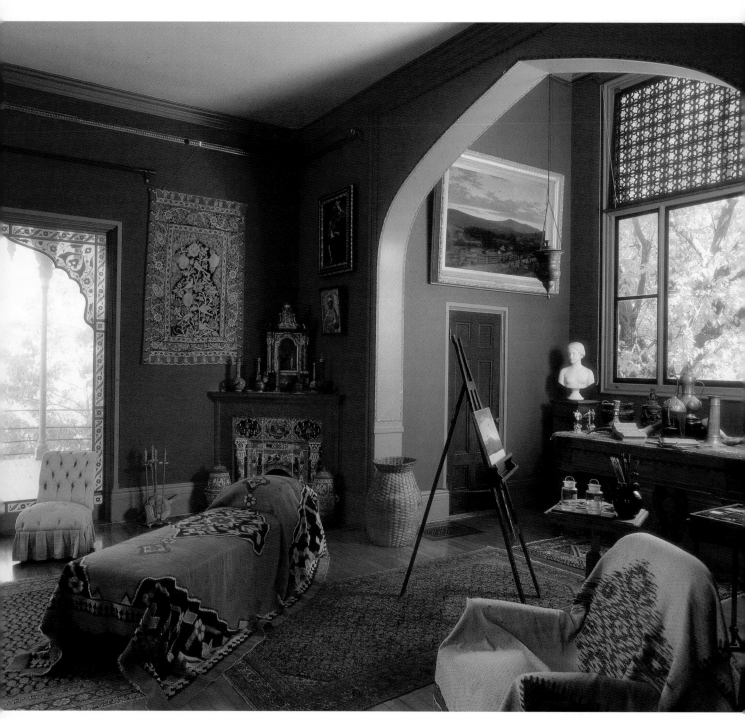

Figure 53. Studio, Olana, 1997 © Kurt Dolnier. The large painting left of the studio window is Church's *Ira Mountain, Vermont* (1850).

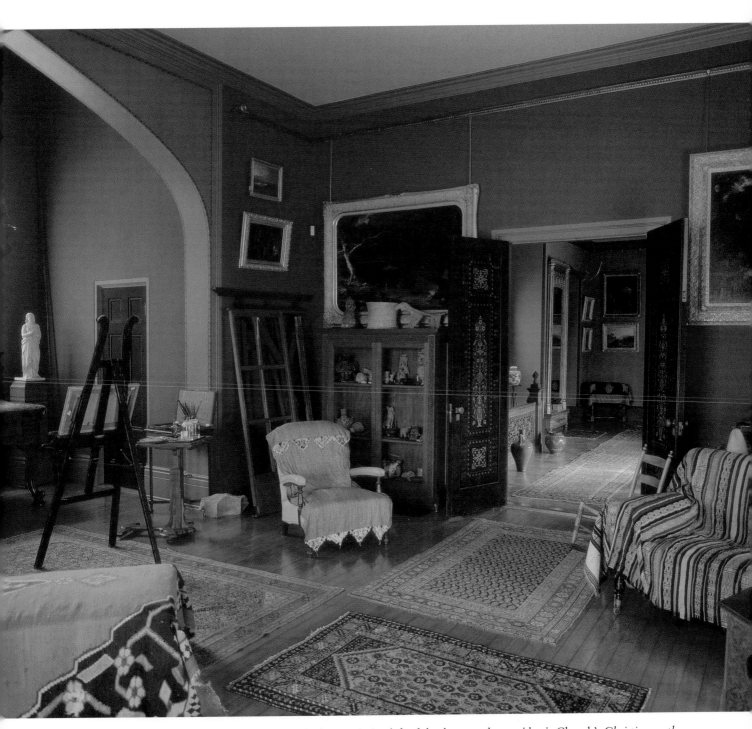

Figure 54. Studio, Olana, 1997 © Kurt Dolnier. The large painting left of the doors to the corridor is Church's *Christian on the Borders of the "Valley of the Shadow of Death," Pilgrim's Progress* (1847).

Erastus Dow Palmer, "I inaugurated the New Studio—it is perfect. Filled with enthusiasm I attacked my first canvas and an Iceberg scene is the result, the best I think I ever painted and the truest."[9] The studio addition is primarily an interior space, indicating that Church envisioned the design from the inside out. He extended the east-west axis of the ground floor to culminate in the view of the Catskills framed by a gilded Moorish window glass. According to Joel Sweimler, the ornate decoration of the studio "reflects Church's creative brilliance, his artistic achievements, his knowledge and appreciation of the world around him, and his devotion [for] ... his chosen career."[10]

COMPLETING
THE LANDSCAPE

Even as he worked on the house, Church continued to elaborate the Olana landscape. Despite the waning of the Romantic style and the growing popularity of high Victorian planting, Church designed in the same natural style. In the mid-1880s, his interest in the landscape intensified: "I have made about 1 3/4 miles of road this season, opening entirely new and beautiful views. I can make more and better landscapes in this way than by tampering with canvas and paint in the studio."[11] The complex spatial composition that Church created may be better understood through its five components: the house and its immediate surroundings, the south park, the farmstead, the woodland buffers, and the roads.[12]

Nestled in the hillside seventy-five feet below the crest of Long Hill, the house is the center of Olana's landscape composition.[13] To the west of the house, the hill drops abruptly, covered in underbrush. To the north, the carriage house, stable, and laundry yard are screened by trees. To the east is a manicured lawn across which visitors first see the full mass of the house. And to the south is a two-tiered lawn terrace that provides a viewing platform and a transition to the south park below. On the west and north sides the transition from the house to undergrowth and woodlands is immediate.

The south park, situated between the house and the lake, is an ornamental landscape "carefully planned and planted in imitation of nature over a period of thirty years."[14] The primary function of the south park is visual. From the house, it provides a middle ground between the viewer and the far ground of river and mountains. Within the park one experiences a series of changing views, the most important of which is the house framed by the woods and capped by the sky (figure 52). The lake forms the park's southern boundary, providing a visual plane where the eye can rest and illuminating the park with reflections of the house, trees, and sky.[15]

The farm occupied one-half of the acreage and was an important part of life at Olana. For the house, the farm produced vegetables and cut flowers. It also produced cash crops that included hay, oats, rye, corn, apples, cherries, grapes, peaches, plums, pears, and strawberries.[16] At the same time, Church made aesthetic use of the farmstead, creatively manipulating the views of pastures, fields, and orchards.

Thick woodlands surrounded the house, park, lake, and farmstead. The woods visually separated the varied uses of the property and buffered the property from the world outside. The original land that Church purchased was largely cleared, since it was used for farming. In replanting much of the Olana property, Church was working out his design for the grounds. In 1890, a reporter for the *Boston Sunday Herald* commented, "The multitude of trees planted under Mr. Church's direction a quarter of a century ago now give convincing evidence of his wise foresight and prompt action when he first came here."[17]

Some five-and-one-half miles of roads traverse the property. In a Romantic landscape, the roads were of utmost importance, as they entailed the composition of myriad scenes—contrasting open pastoral views, dark hemlock forests, sun-dappled woodlands, and serene bodies of water. Church's careful placement of the carriage roads allowed these contrived scenes to be viewed in an orderly sequence of experiences. Thus the visitor would see the landscape through Church's sensibilities. Although to today's visitor the roads may appear the same visually, the nineteenth-century visitor would have acknowledged a variety of experiences.

There are several farm roads, two ceremonial entrance roads, and three pleasure roads. The farm roads were strictly utilitarian, providing access to the farm buildings and the surrounding fields. The first approach to the property was the South Road (figure 55), built in the early 1860s and described in 1884 as "direct, and ... open, the road being chiefly lined by

Figure 55. John A. Eberle, *South Road, Olana,* 1906, gelatin paper, 12 x 10 in.

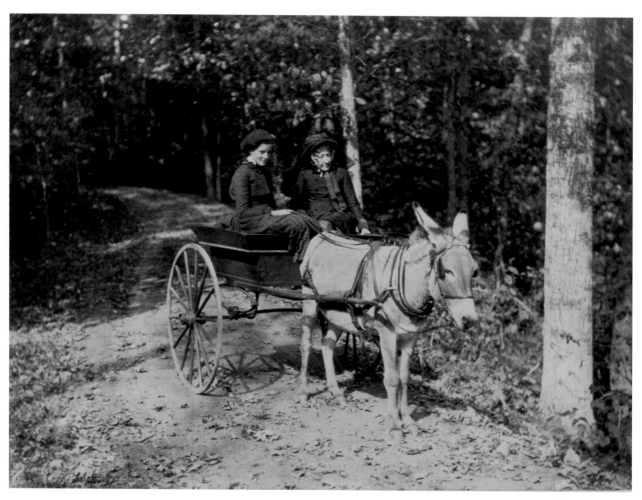

Figure 56. Robert and Emily de Forest, *Isabel Charlotte (Downie) Church and her Grandmother, Emma Carnes,* October 11, 1884, albumen print, 8 1/2 x 6 1/2 in. On a pleasure drive with a white Syrian donkey that Church brought back from his Middle-Eastern journey.

evergreens, shrubbery and sumach. It passes near the borders of a pretty lake."[18] The road gently ascended the hill, revealing panoramic views across the south park studded with specimen trees, passed Church's studio, and approached the house, which was "hardly seen until you are directly upon it."[19] An extension to the South Road, built in 1886-87, crossed the upper portion of the south park directly below the house and provided an interplay between the near and the far distance, between the house, the lake, and the Catskills. The second approach to the property was the North Road, built in 1868 and "a winding and wooded road, which constitutes a considerable drive in itself. The hill is very precipitous here, and one looks down at times upon this road directly below him in an almost inaccessible gulf."[20] Again the house was hidden by trees

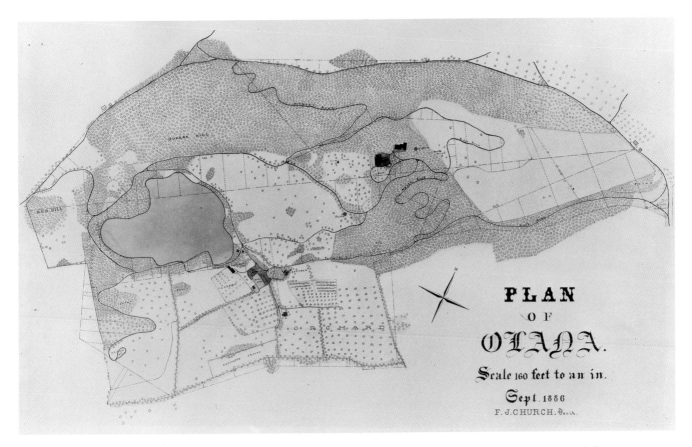

Figure 57. Frederic Joseph Church, *Plan of Olana*, September 1886, ink and watercolor on paper, 22 1/8 x 36 1/4 in.

and underbrush until one suddenly encountered the east lawn.

The three pleasure drives on the Olana property were the Pond Road, the Crown Hill Road, and the Ridge Road, all built in 1884. On these roads, the Churches took daily recreational drives (figure 56) and had a variety of visual experiences as they circled the lake, passed through pasture land, or drove along the

rim of the western cliffs. The grandest vistas are found along these roads, where Church manipulated the height and route to incite awe. All entrance and pleasure drives lead to and from the house, the center of the property. The appearance of the grounds in 1886 is documented in a map (figure 57) made by Church's son, Frederic Joseph, while an engineering student at Princeton University, then Princeton College.

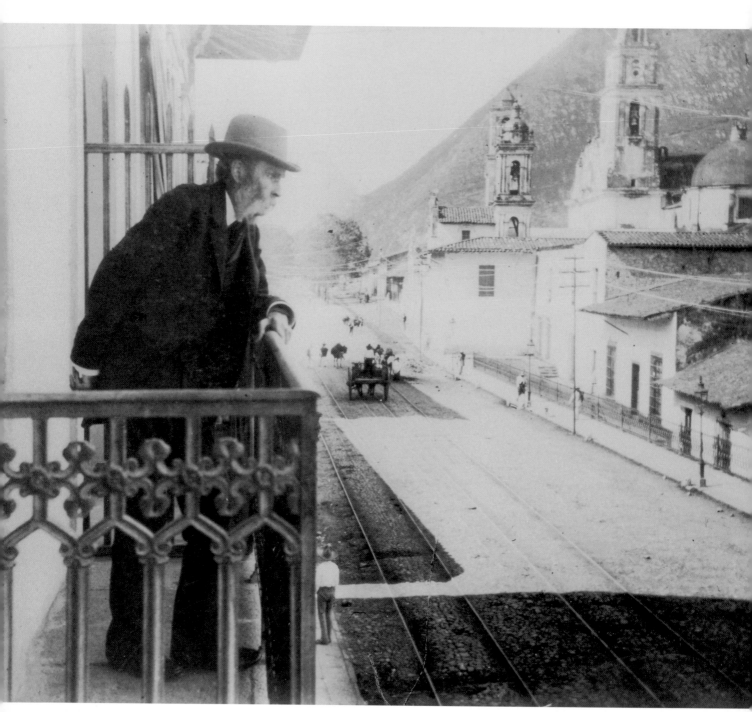

Figure 58. Walter Launt Palmer, *Church on a Balcony in Orizaba, Mexico*, 1895, photograph, 2 1/4 x 3 3/8 in.

CHURCH'S LAST YEARS AT OLANA

Grace King, who visited Olana in August 1891, wrote that she was in "a perfect Eden of picturesque beauty."[1] Church's thirty years of labor to make his property "perfect" had been realized. Despite the comment in a news article the previous year that "Mr. Church admits that his house will never be completed, at least as long as he lives, for every year he conceives some plan by which he can add to its convenience or attractiveness," no new projects are discussed in his correspondence from 1891 to 1900.[2] Instead, the letters from the infirm artist and his wife, now also ill, discuss their concern for each other and their children. In late 1891, Church offered his twenty-one-year-old son Louis the salaried management of the

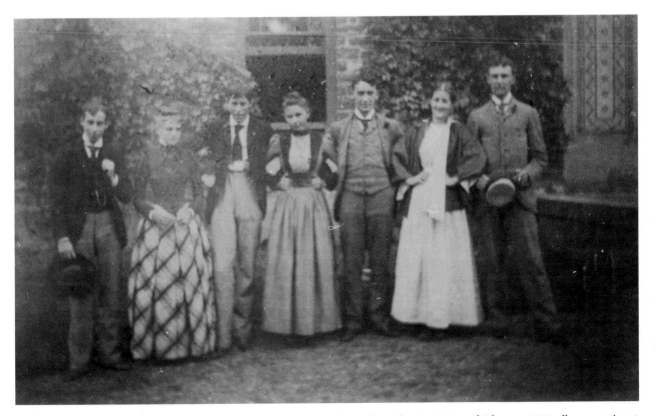

Figure 59. Unidentified photographer: *The Church Children and Friends on the East Lawn of Olana*, c. 1889, albumen print, 4 x 5 3/4 in. Left to right: Louis Church, Unidentified Woman, Theodore Winthrop Church, Unidentified Woman, Frederic Joseph Church, Isabel Charlotte (Downie) Church and Jeremiah Black (later married to Downie).

farm. Louis agreed, provided he was "to have full authority next to you."[3] Isabel Church explained the basis for Church's offer when she wrote her daughter: "Your father thought he needed one of his sons, to take charge, and *Louis*, dear boy is *the* one—There is so much to be looked into at Olana—and Father can not, nor cares to do it."[4] Thus Church withdrew from the active operation of Olana and began its transition to the next generation (figure 59).

As they had almost every winter since the 1880s, Frederic and Isabel Church spent the summer and fall at Olana. After Christmas, Church departed for Mexico where he found "a climate more suited to his health"[5] (figure 58). Isabel's physicians prescribed that she spend the winters at the seashore. The couple reluctantly separated, and she traveled to Florida or Bermuda. In January 1890, Church made a will bequeathing Olana to Isabel.[6] After her death on 12 May 1899, he wrote a new will, this time bequeathing Olana and its contents to Louis.[7] When the aging artist left early for Mexico that winter, his thoughts, as always, returned to Olana. He confided to the widowed Virginia Osborn:

I have good news from my family and everything at Olana is most satisfactory. I miss my dear Isabel as much as ever and often feel that it would have been a blessing if I could have passed away when she did—but it is all for the best. There are still duties and wholesome pleasures which give each day an interest not to be despised.[8]

In the spring of 1900, in failing health, Church returned to New York City but was not able to proceed to Olana. He died on 7 April 1900 at the Osborn family home in New York City, where Isabel had died the previous year. Obituaries appeared in all the major newspapers, most eulogizing his work. One writer recalled that the artist "learned to admire Persian architecture, which is exemplified in a modified form at his magnificent country home at 'Olana' on the Hudson River, one of the most notable houses in the United States, situated in a vast park beautified by the taste of the artist."[9]

Perhaps a more fitting tribute appeared in an earlier news article about Olana:

As I looked from its broad veranda one beautiful sunshiny morning the scene that spread before me filled me with regret that I had the soul of an artist without the power to wield the brush. It seemed the spot of all others to lend inspiration, and it is no wonder that the fame of Mr. Church is so great and lasting as to live long after he has gone to his last resting place.[10]

Figure 60. Frederic Edwin Church, *The Hudson Valley in Winter from Olana*, c.1871-72, oil on paper, 20 1/4 x 13 in.

Figure 61. Unidentified photographer, *Louis Palmer Church*, n.d., platinum print, 8 3/8 x 6 5/16 in.

OLANA AFTER FREDERIC CHURCH

Shortly after Frederic Church died in April 1900, the Metropolitan Museum of Art in New York City honored him with an exhibition of ten of his most significant paintings. Accompanying these works was a catalogue written by friend Charles Dudley Warner, who suggested that Church's great achievement was to foster in ordinary Americans "an enthusiasm for landscape art ... as an expression of the majesty and beauty of the divine manifestation in nature. ... He aspired to interpret nature in its higher spiritual and aesthetic meaning."[1]

Mostly, however, Church's fame as a celebrated American landscape painter was a dim memory by 1900. A revival of interest in his work would not fully begin until 1966 when art historian David Huntington published *The Landscapes of Frederic Edwin Church*, which included biographical information and informed interpretation of Church's work.[2] In 1979, Church's 1861 work, *The Icebergs*, was purchased by the Dallas Museum of Fine Arts for $2.5 million, at the time the highest price ever bid at an American art auction. Suddenly, the world took notice of Church and American landscape painting.[3]

Perhaps the most important recent event to revitalize Church's place as a major painter was the 1989 exhibit, "Frederic Edwin Church," organized by the National Gallery of Art in Washington, D.C. Significantly, the exhibition catalogue included, among its four main entries, an essay on Olana, which was called the "last great work" of Church's life.[4]

That catalogue essay, revised and updated, comprises the major portion of this book on Olana but does not discuss the fate of the property after Church's death. This afterword, therefore, brings the story of Olana up to the present and answers two questions often asked by visitors. First, how was such an unusual place like Olana maintained and preserved during the more than half century when Church's name and works were largely forgotten? Second, how did Olana become a New York State Historic Site that is now one of the major tourist attractions in the Hudson Valley?

LOUIS AND SALLY CHURCH'S STEWARDSHIP OF OLANA

Born in April 1870, Louis Palmer Church was the youngest of Frederic Church's three sons and played a major role in the preservation of Olana.[5] Like his older brothers, Louis attended St. Paul's, a private school in Concord, New Hampshire, and graduated in 1887. In 1891, he was asked by his parents to take over the management of Olana. Within a year, his father doubled Louis's salary, but the young man contemplated a business career away from Olana. As his parents became increasingly frail, however, Louis sacrificed his own future to care for them. From the early 1890s until their deaths in 1899 and 1900, he accompanied one or the other of his parents to, among other places, Mexico and Florida in a search for more salubrious winter climates.

Engaged in 1894, Louis married Sarah Baker Good, better known as "Sally," in January 1901 in Lock Haven, Pennsylvania, Sally's hometown (figures 61 and 62). Several of Sally's six brothers and sisters maintained a friendship with the couple, including

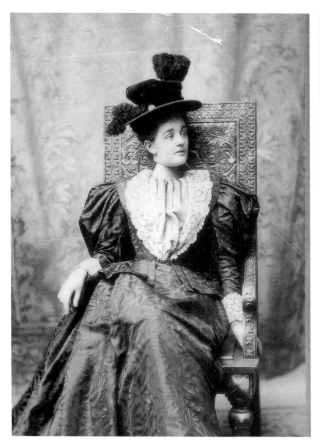

Figure 62. W. Floyd, *Sally Good Church*, c. 1885, albumen print, 6 1/2 x 4 5/16 in.

Sally's sister Blanche, who later married lawyer Charles Tressler Lark. Eventually, Blanche's son, Charles Lark, Jr., would inherit Olana.

After a honeymoon in Europe, the newlyweds returned to Olana, and Louis became owner of the property he had already managed for ten years. The couple lived much as Frederic and Isabel had: supervising the operations of the farm, taking care of pets, and enjoying the grounds and the views. The couple had no children but, like Louis' parents, entertained relatives and friends, including Susan Hale and Lockwood and Meta de Forest.

Though he made numerous improvements on the buildings and landscape, Louis instituted no radical changes at Olana. Around 1915, he created an elaborate flower garden on the lawn directly east of the house (figure 63) and, sometime between 1909 and 1917, electrified the house by installing a gas-powered generator under the west porch of the studio wing. By 1903, the couple had purchased their first automobile, which they used for excursions on and off the property. They continued to maintain a staff of servants in the house.

Louis and Sally also spent time away from Olana. Louis made improvements to a cabin that his father had built in the 1870s on the shores of Lake Millinocket near Mount Katahdin in Maine. The couple spent some weeks there each year, fishing, canoeing and entertaining friends. They also built a cottage in Port Sewell, Florida, on the grounds of the Sunrise Inn, a well-known resort hotel. Here, the couple passed most winters, tending a rose garden and deep sea fishing.[6]

Louis and Sally made few changes inside the main house at Olana. Occasionally, they made gifts of Church's artwork to close friends, and Louis may have sold a few of the dining room's old master paintings. The most significant dispersal was the couple's donation in 1917 of over 2,000 pencil and oil sketches to New York City's Cooper Union Museum (today's Cooper-Hewitt Museum), which was assembling a study collection of drawings by American artists. The couple kept all framed works by Church, most of the artist's sketches done from Olana, and all of his architectural sketches, drawings, and plans.

Louis and Sally installed a radio in the dining room and a television in the sitting room. They added some new furniture, replaced worn upholstery, and rearranged some rooms, most importantly, the court hall. Overall, however, the couple left the basic decorative scheme of the house in place so that, when Charles Lark, Jr., inherited Olana in 1964, the interior was more or less the way it had been when Louis had taken ownership in 1900.

In November 1943, Louis died in his bedroom at Olana at the age of seventy-three. With the assistance of long-time help Ruben and Ellen Wilsey, Sally attempted to maintain the farm, but she had little experience with financial matters and was hampered by health problems. By 1946, Sally leased the farm to tenants, and the Wilseys lived in the main house with Sally, continuing as caretakers and gardeners. In the late 1940s, nearby Germantown realtor Lloyd Boice was hired to oversee the property.[7] He became liaison between the Wilseys and Sally's nephew, Charles Lark, Jr., who took over her financial affairs after his father died unexpectedly in 1946.[8] After the death of Sally's sister Blanche Lark, Charles Lark, Jr., became Sally's sole family advisor. Her health continued to deteriorate, and she was declared mentally incompetent in 1960. For the last decade of her life, Sally was cared for

Figure 63. Unidentified photographer, *East Lawn with Flower Garden,* c. 1930, 4 x 3 7/8 in.
Landscape modifications made by Louis Church.

by nurses and lived as an invalid at Olana. She died in her sleep on 17 August 1964, at the age of ninety-six.

Throughout her sixty-three-year tenure at Olana, Sally seemed to have had an instinctive sense of its potential artistic and historical significance, perhaps because she had first known the Churches in the 1880s and had observed Frederic and Isabel's efforts at creating a singular environment for their family. In interviews, former servants at Olana describe Sally's insistence on maintaining the interior exactly as it had been in Frederic Church's time. As one former servant explained, "You didn't dare touch anything."[9] Even in her last years, Sally held firm to an interest in preserving the house. In 1955, for example, she insisted on replicating the original stenciling on the house's exterior cornices, though Lloyd Boice and Charles Lark, Jr., did not implement the plan because of its sizable expense.[10]

The Saving of Olana

After Sally died, Olana was willed to Charles Lark, Jr., who lived in Hackensack, New Jersey, and who did

Figure 64. Lloyd Boice, c. 1965 © Neefus Photographers.

not wish a home in the upper Hudson Valley. The fate of Olana was only too obvious. Unusual Victorian houses like Olana were very much out of fashion, and American art did not command high prices. Only a few months earlier, the contents of Thomas Cole's home directly across the Hudson from Olana in Catskill had been auctioned from the front porch of the house.

In early September, David Huntington, a 42-year-old art history professor at Smith College, received a call from Stuart Feld, then a curator at the Metropolitan Museum of Art (figure 65). "Do you know," Feld asked, "that Mrs. Church has died?"[11] Huntington called Charles Lark, Jr., who explained that the contents of Olana were indeed to be auctioned. Shocked, Huntington asked two favors of Lark: first, he requested permission to document Olana; second, he asked for a grace period to organize a campaign to save the property from dispersal.

At the time, Huntington was the foremost Church scholar in the United States. While doing dissertation research at Yale University in the early 1950s, he had been the first American art historian to rediscover Church's work. From Charles Lark, Jr., the young scholar had gained permission to do research at Olana, and he first visited the house in December, 1953.[12] In a 1988 interview, he described that first encounter with the remarkable property:

> I went into the house absolutely bewildered by what I saw, not at all expecting such a relic of the nineteenth century, almost virtually untouched, unchanged since the nineteenth century.
>
> I had lunch with Mrs. Louis Church, who was senile and wanted to feed me much more than I really wanted to eat. The staff said that I would have to make it appear that I was just there for lunch, and then I would leave by the front door and say good-bye to Mrs. Church. They told me where I could park my car out of sight. ... Then they said, "You just come in the back door, and we'll let you up into the attic through the back stair."
>
> I was absolutely staggered in the attic. Just the abundance of the material that was still there—hundreds of drawings by Church, scores and scores of oil studies by the painter,

cancelled checks, journals, prints that the artist had, photographs (hundreds upon hundreds), some paintings by other artists, paintings by the artist himself ...[13]

After being assured by Lark that he would be given time to try to save Olana, Huntington immediately began contacting individuals who might be helpful. He wrote letters, made telephone calls, and presented lectures. He gave the drive a sense of urgency and bolstered enthusiasm when it flagged. Crucial to Huntington's efforts was Lloyd Boice, the overseer of Olana before and after Sally's death (figure 64). Convinced of the importance of Huntington's campaign, Boice worked to enlist local interest and to help sway the executors that they should delay dispersal of the estate.[14]

On 11 November 1964, the formation of Olana Preservation, Inc., was announced. An informal agreement was reached with the estate to rent the house. On 12 June 1965, Alexander Aldrich, president of Olana Preservation, signed a lease on the estate with an agreement to purchase the property for $470,000.[15] In spite of this arrangement, the executors of Sally Church's estate made plans for its dispersal. All paintings from the house were transported to New York City for appraisal by the auction house Sotheby, Park Bernet. O. Rundle Gilbert, an auctioneer specializing in estate sales, inventoried and tagged every item in the house. Professional appraisals were made of jewelry and important manuscript items. It was only too clear that, should Huntington and Olana Preservation be unsuccessful, the sale of Olana and its contents would quickly proceed.

The fund-raising campaign was arduous and fast-moving. The historic preservation movement was in its infancy, and the art of Frederic Church was largely unknown. To promote awareness of both Church and Olana, an exhibition of his works was mounted at the National Collection of Fine Arts, Smithsonian Institution, in February 1966, by Richard Wunder, curator at that institution, and Huntington.[16] This exhibition was also shown at the Albany Institute of History and Art and at M. Knoedler & Co., in New York. Mrs. John F. Kennedy served as the honorary chairperson for a fund-raising benefit at Knoedler's.

Figure 65. Nancy Graeff, *David Huntington at the Back Door of Olana*, 1989.

At the same time, Huntington published *The Landscapes of Frederic Edwin Church*, a book that would go far to give legitimacy to the study of American art and Church.[17] Huntington later recalled that "The whole book was being rushed at a terrific pace because [the publisher] wanted to capitalize understandably on the campaign. I wrote the book with real passion and a sense of urgency."[18]

Church and Olana were little known, however, and after almost two years of fund-raising, Olana Preservation had raised only $300,000. The Board approached New York State Governor Nelson Rockefeller, a major patron of the arts. Also, in mid-May 1966, *Life* magazine published a dramatic article on Olana with stunning photographs by Henri Daumon. The title read, "A century-old refuge of art and splendor—Must this mansion be destroyed?"

A key factor for the campaign proved to be a bill introduced into the New York State Legislature by Assemblyman Clarence Lane and Senator Lloyd Newcombe, both local legislators. Amid a wave of publicity, political pressure, strong local citizen interest, and editorial and news support from *The New*

Figure 66. Governor Rockefeller Signing the Lane-Newcombe Bill, 27 June 1966. Left to right: Assemblyman Clarence Lane, Senator Lloyd Newcombe, Governor Rockefeller and Alexander Aldrich, President of Olana Preservation. Courtesy of the Rockefeller Archive Center.

Figure 67. Governor Rockefeller and Some Other Key Individuals Involved in Saving Olana, 27 June 1966. Left to Right: Unidentified man, Roland Redmond, David Huntington, J. William Middendorf II, Elizabeth Aldrich, Alexander Aldrich, Governor Rockefeller, Mrs. William H. Osborn, Raymond C. Kennedy, James Biddle and Donald Karshan. Courtesy of the Rockefeller Archive Center.

York Times, the Lane-Newcombe bill passed the legislature on June 22. David Huntington received the following telegram: "BILL TO AUTHORIZE PURCHASE OF OLANA BY NEW YORK STATE PASSED SENATE UNANIMOUSLY TODAY AND NOW GOES TO GOVERNOR FOR SIGNATURE. CONGRATULATIONS."

On 27 June 1966, Governor Rockefeller, standing at Olana's arched entrance, signed the bill into law (figures 66 and 67). On June 30, Olana Preservation

advised the executors of Sally Church's estate that it was exercising its option to acquire Olana. The campaign raised $388,768.49 from the public. The cost to mount the campaign and rent the house was $92,244.33. The State of New York contributed approximately $189,000 toward the final purchase price. Olana Preservation purchased Olana on 29 July. On 13 December 1966, Olana Preservation conveyed title to the State of New York.

Olana opened its doors to the public on 3 June 1967, as a New York State Historic Site operated by the New York State Office of Parks, Recreation and Historic Preservation (OPRHP). Volunteers who had struggled so arduously to save the house continued to work for its success. Under the direction of Richard Slavin, the first site manager, a group of persons active in Olana Preservation formed Friends of Olana, a not-for-profit support organization.

On 28 May 1971, the New York Board of Regents granted a charter to Friends of Olana. Beverly Finn, Anna Kennedy, Mary Mazzacano, Marion Neefus, and Lilian Reineck were listed as the incorporators. The Reverend James Elliott Lindsley served as the first president. The founding purpose of Friends was to advocate for and support the preservation of Olana, to sponsor education programs, and to foster scholarly research on Frederic Church and Olana.

In 2000, Friends of Olana had some 800 members and its achievements included the purchase of collections objects for the site, the conservation of works of art, the sponsorship of curatorial positions, and publication of art historian Gerald L. Carr's two-volume *Frederic Edwin Church: Catalogue Raisonné of Works of Art at Olana State Historic Site*.[19] In 1998, Friends of Olana and OPRHP drafted a *Comprehensive Plan*, which envisions Olana as an international tourist destination that includes a fully restored main house; a restored historic landscape with original carriage drives, parkland, gardens, and views; and a museum/visitor center to display the work of Frederic Church from Olana's own collections as well as exhibitions drawn from other collections. In 2000, the board of trustees of Friends of Olana voted to change the name to "The Olana Partnership," a shift reflecting a greater effort to reach out to diverse regional interests and to more intensively promote Olana and the museum/visitor center.

Today, Olana comprises 336 acres, including the original historic property of 250 acres as well as adjacent lands acquired by Louis Church and the State of New York. Olana's collections number some 40,000 objects, including paintings by Church and other American artists as well as over 1,000 oil and pencil sketches by Church, some 1,200 prints and drawings by other artists, Church's library of over 1,800 volumes, and over 5,700 photographs documenting family, friends, house, grounds, and foreign lands and peoples. Annually, some 150,000 people visit the Olana property, and more than 25,000 people tour the house.

By the end of his life, Church could no longer paint and, instead, focused his creative energies on Olana. Erected over a thirty-year period, the farm, the pleasure grounds, the main house and its collections together comprise a unified vision. The artifacts of human civilization—from Persian stenciling to old master paintings—are united with the elements of Divinely-created nature—river, mountains and sky. Here, the Church family lived a life filled with friendship, conversation, laughter, reflection, duty, and worship.

Increasingly, Olana is recognized as Church's last great artistic effort carried out, not in paint, but in landscape, architecture, and interior design. Olana is an artwork that the Church family found eminently livable. Today, visitors to Olana are also touched by the sense of home they find there, where the creations of people and nature, the human and the Divine, merge in domestic and artistic harmony.

—David Seamon and Karen Zukowski
2001

NOTES

CHAPTER 1.
PAINTING, MARRYING, AND STARTING A HOME

1. In addition to those whose help is acknowledged in individual footnotes, I wish to recognize David Huntington, Gerald Carr, Joel Sweimler, and Elizabeth Aldrich Elliott, who read earlier drafts and provided valuable criticism. I also wish to thank David Seamon, whose advice and assistance are reflected in all aspects of this essay. Finally, I wish to thank the staff of the New York State Office of Parks, Recreation and Historic Preservation at both the Taconic Regional Office and the Bureau of Historic Sites.

2. Andrew Jackson Downing, *A Treatise on the Theory and Practice of Landscape Gardening, Adapted to North America, with a View to the Improvement of Country Residences* (New York, 1859), 327-38.

3. Frederic Church to Thomas Cole, 17 October 1846, Detroit Institute of Arts, Michigan. All quotations from correspondence are rendered exactly as written, with punctuation and spelling intact.

4. Marshall Tymn, ed., "Lecture on American Scenery: Delivered before the Catskill Lyceum, April 1, 1841," in *Thomas Cole: The Collected Essays and Prose Sketches* (St. Paul, Minn., 1980), 206. I am grateful to Donelson Hoopes for this reference.

5. This sketch is in the collection of the New York State Office of Parks, Recreation and Historic Preservation, Taconic Region, Olana State Historic Site, OL.1980.1333, hereafter referred to as Olana. Gerald Carr associated this Church sketch with a visit that Church made to Red Hill with Cole. See Gerald L. Carr, *Frederic Edwin Church: Catalogue Raisonné of Works of Art at Olana State Historic Site*, 2 vols. (New York, 1994), 64-65. This work was commissioned by Friends of Olana, Inc. Also see Gerald L. Carr, *In Search of the Promised Land: Paintings by Frederic Edwin Church* [exhibition catalogue] (New York, 2000), 44-46, 101.

6. Frederic Church to William H. Osborn, 30 November 1868, transcript, New York State Office of Parks, Recreation and Historic Preservation, Olana State Historic Site, David C. Huntington Archive, Hudson, New York (hereafter referred to as Olana Archive), Estate of Sally Good Church Papers. William Osborn (1820-94) was the owner of the Illinois Central Railroad and one of Church's closest friends and foremost patrons.

7. John I. H. Baur, ed., "The Autobiography of Worthington Whittredge, 1820 - 1910," *Brooklyn Museum Journal*, (1942): 29. Gerald Carr gave me this text.

8. "[Correspondence of the Transcript]," *Boston Evening Transcript*, 10 January 1860. Gerald Carr and Merl M. Moore, Jr., provided this reference.

9. Isabel Carnes was the daughter of Francis and Emma (Osgood) Carnes. Her father, a graduate of Harvard and trained as a lawyer, was persuaded by a cousin to form a dry-goods and import business. He was described in a pamphlet, *Wealth and Biography of the Wealthy Citizens of New York City* (New York, 1845), (Olana Research Collection) as "a gentleman ... [who] Resided a long while in Paris, where he was held in great consideration both among his countrymen and by the elite of French society, for his fine taste, classical acquirements, polished manners, and ready wit. He is yankee born, of great respectability." Of greater interest than his antecedents and accomplishments—and the true reason for his inclusion, the pamphlet notes—was that his wife and daughters had come into an inheritance of $200,000. I am grateful to Sally Bottiggi, Kristin Gibbons, and Joel Sweimler for this information.

10. Sarah Osgood Tucker to Isabel (Downie) Church Black, 16 May 1900, Olana Archive, Estate of Sally Good Church Papers.

11. Church to Thomas Appleton, 10 January 1860, Olana Archive, Estate of Sally Good Church Papers. Additional evidence of Church's joy at his engagement is found in a letter of consolation, written at the painter's death, to his daughter by an elderly relative: "... he was radiantly happy in the feeling that he had, at last, found the realization of his dreams in her." Tucker to Black, 16 May 1900, Olana Archive, Estate of Sally Good Church Papers.

12. Church purchased the property from Levi and Gertrude Simmons, who had bought it in 1853. The property was known as the Wynson Breezy farm, a corruption of the name of the farmer who apparently first developed it. Wynsant Brezie or Brisea (d. 1802) had rented or mortgaged the 126 acres from John Jay Van Rensselaer of Crailo on 26 September 1794. Columbia County Clerks Office, Mortgage Book A, 297; and Deed Book 13, 283. I am grateful to Kristin Gibbons, formerly of the Bureau of Historic Sites, New York State Office of Parks, Recreation and Historic Preservation, for uncovering this information.

13. Frank J. Bonnelle, "In Summer Time on Olana," *Boston Sunday Herald*, 7 September 1890, and "The American Rhine," *New York World*, 21 July 1889, Olana Research Collection. After Cole's untimely death from pneumonia in 1848, Church had painted *To the Memory of Cole* (1848), which depicted the Catskill Mountains as Cole's monument.

14. "The Kaatskills, Their Attractions Enthusiastically Set Forth," in an unidentified magazine clipping with the heading "No. 1,141—vol. V," c. 1871. Vedder Library, Greene County Historical Society, Coxsackie, New York. Raymond Beecher kindly brought this article to my attention.

15. Theodore L. Cuyler, "A Sabbath in the Catskills," in *The Catskill Mountains*, Charles Rockwell, ed. (New York, 1867), 260. Cited in David Huntington, "Frederic Edwin Church, 1826-1900; Painter of the Adamic New World Myth" (Ph.D. diss., Yale Univeristy, 1960), 145.

16. No renderings of the elevations or floor plans exist, but a bill from Hunt to Church, dated 1 April 1861, "For architectural services rendered up to date—$125," is in the Olana Archive, Estate of Sally Good Church Papers.

17. These paintings, OL.1981.12 and OL.1981.11, respectively, are in the collection of Olana State Historic Site. Through newspaper clippings provided by Frances A. Hoxie of the Connecticut Historical Society, Gerald Carr uncovered the fact that these paintings celebrated the children's births.

18. Letter from Frederic Church to Joseph Church, 13 May 1864, Olana Archive, Estate of Sally Good Church Papers.

19. Henry T. Tuckerman, *Book of the Artists* (New York, 1867), 375. Tuckerman, an art critic, and Church were long-time friends.

1. Charles H. Smith, *Landscape Gardening: or Parks and Pleasure Grounds* (New York, 1853), 287.

2. Smith, 289. While Smith largely advises on the selection and planting of trees, on the design of roads and the creation of an artificial lake, Smith's text emphasized that the landscape gardener "is supposed to create a landscape in living nature, just as the painter creates one on canvas."

3. Church was not adverse to earth moving on a grand scale. In the 1870s, he wrote Lord Dufferin, the Governor-General of Canada from 1872 to 1878, regarding Niagara Falls that, "the natural formation of the rocks seemed to invite some artistic treatment especially by cutting channels for the purpose of forming picturesque cascades which would not only greatly enrich and diversify certain portions but also do much toward harmonizing the general effect." A letter from Frederic Church to Lord Dufferin quoted by Thomas V. Welch, in Charles M. Dow, *The State Reservation at Niagara*, (Albany, New York, 1914), 12. Gerald Carr pointed this quotation out to me.

4. Smith, 135.

5. Bonnelle. Bonnelle, a newspaper reporter, and Church became friends and the article seems to be accurate.

6. Bonnelle.

7. Letter from Frederic Church to William H. Osborn, 16 May 1870, transcript, Olana Archive, Estate of Sally Good Church Papers.

8. The deaths of these babies, Herbert on 18 March 1865, and Emma on 26 March 1865, affected the Churches as few other events in their lives. The artist, Horace Robbins, described the event to his mother, "For some three or four days previously Mr. Church's eldest child Herbert who was over two years old and beginning to be most interesting—was a little sick—tho [sic] the parents were not much alarmed in regard to him. He was sick with the dysentery But Friday last, he was much-worse & all that 1 day & Saturday last—Mr. Church did not come to the Studio—and on Saturday at 10.P.M. the dear little fellow died. ... Poor Mr. Church is almost broken down—he and his wife were so 'wrapped up' in their only son. ... I hear that the little baby is sick too, with the same trouble." Letter from Horace Robbins to his mother, 21 March 1865, transcript, Olana Research Collection. I am grateful to Mrs. Mary Rintoul, the owner of these letters, for loaning them to Olana State Historic Site and for allowing transcriptions to be made. The letters were uncovered through the efforts of Kristin Gibbons and Gerald Carr. Pearl Capone transcribed those sections of the letters that discuss Frederic Church.

9. Letter from Horace Robbins to his mother, 18 May 1865, transcript, Olana Research Collection.

10. Robbins, 18 May 1865. Letter from Horace Robbins to his mother, 30 June 1865, transcript, Olana Research Collection. A description of Church at work is found in the same letter: "Mr. Church with all his immense natural gifts—has as the result of long years of practice & work—acquired a rapidity which is wonderful to think of and at the same time making his sketches exceedingly elaborate and accurate. He will finish several, finely, while I am completing one and that imperfectly. ... He works with an energy & constancy unequaled by anyone. Every day of my life I am more & more convinced that he is the only great landscape painter we have, he is a giant among pigmies [sic]—and there is an earnestness & truthfulness about all he does which I have not seen the likes of in any others productions."

11. Letter from Frederic Church to Theodore Cole, 28 July 1865, Olana Archive, Estate of Sally Good Church Papers.

12. Letter from Frederic Church to William H. Osborn, 1 January 1866, transcript, Olana Archive, Estate of Sally Good Church Papers.

13. I am grateful to Gerald Carr for this insight. These associations are discussed in Gerald Carr, *Frederic Edwin Church: Catalogue Raisonné of Works of Art at Olana State Historic Site*, 311-316.

14. Church wrote his father in 1864: "I understand that the piece of woods at the North of my farm on the top of the hill can be had at the price asked three years ago $2000." Hence, Church considered purchasing the hilltop in 1861 and again in 1864. Letter from Frederic Church to Joseph Church, 13 May 1864, Olana Archive, Estate of Sally Good Church Papers. Church finally bought the property on 23 October 1867. He paid $3,500 for it.

15. Letter from Frederic Church to Erastus Dow Palmer, 22 October 1867, McKinney Library, Albany Institute of History and Art, Albany, New York.

16. Church studied in an architect's office in 1867, before he left for the Middle East. According to a letter written by Isabel's cousin, Mrs. Henry de Forest, to her son, Lockwood, Church advised her that Lockwood should, "pass a few weeks in an architect's office as he [Church] did before he went to Syria." Letter from Mrs. Henry de Forest to Lockwood de Forest, 15 August 1875. Quoted in Anne S. Lewis, *Lockwood de Forest: Painter, Importer, Decorator* (Huntington, New York, 1976), 6. As Hunt was the architect for the proposed house and both men "officed" in the Studio Building, it seems likely that Hunt's atelier might have conveniently welcomed the artist. A large number of drawings of Classical structures, in the collections at Olana, are the likely result of this architectural study.

17. John Davis, "Frederic Church's 'Sacred Geography'," *Smithsonian Studies in American Art*, 1, no.1 (Spring 1987), 81.

18. Davis, 81; Church's library at Olana contains numerous volumes on the Middle East, including history, science, biblical studies, travel guides and romance novels. I am grateful to Gerald Carr and Robin Eckerle for pointing out the large number of romance novels in the library.

19. Letter from Frederic Church to William H. Osborn, 13 January 1868, transcript, Olana Archive, Estate of Sally Good Church Papers.

20. Letter from Frederic Church to Martin Johnson Heade, 22 January 1868, Archives of American Art, Smithsonian Institution, Washington, DC, roll D5, frames 633-634.

21. Davis, 90. This article is an excellent examination of Church's journey to the Middle East. Though the artist's home is not discussed directly, the article provides a basis for understanding the construction of Olana and the acquisition of its contents.

22. Letter from Frederic Church to William H. Osborn, 29 July 1868, transcript, Olana Archive, Estate of Sally Good Church Papers.

23. Davis, 90. Also see John Davis, *The Landscapes of Belief: Encountering the Holy Land in Nineteenth-Century American Art and Culture* (Princeton, NJ, 1996).

1. Letter from Frederic Church to Erastus Dow Palmer, 10 March 1868, McKinney Library, Albany Institute of History and Art, Albany, New York.

2. Bonnelle.

3. Lockwood de Forest, undated manuscript. Archives of American Art, Roll 2730, frame 20.

4. Letter from Isabel Church Black to Charles Dudley Warner, 23 September 1899, Olana Archive, Estate of Sally Good Church Papers.

5. Letter from Frederic Church to William H. Osborn, 9 November 1868, transcript, Olana Archive, Estate of Sally Good Church Papers.

6. Letter from Church to William H. Osborn, 4 November 1868, transcript, Olana Archive, Estate of Sally Good Church Papers.

7. Letter from Church to William H. Osborn, 9 November 1868, transcript, Olana Archive, Estate of Sally Good Church Papers.

8. Letters from Frederic Church to Erastus Dow Palmer, 7 July 1869 and 4 August 1869, McKinney Library, Albany Institute of History and Art. Church was even more explicit concerning his reasons for building with his friend and financial advisor William H. Osborn: "I have got plenty of capital ideas and new ones about house building. As soon as I can afford it, I shall build a modest substantial house for a permanent home." He then proceeded to outline his reasons: "[First,] After all, at my age [he was 42] one ought not to postpone longer than necessary the acquisition of such a home....[Second,] our little cottage is all well enough but we are always cramped....[Third,] it has not enough conveniences for my wife's comfort— and [Fourth, prefiguring the next several years of concentrated work on the house] I have no opportunity for adding the thousand little improvements—which I could do to a more substantial residence." Finally, summing up the past seven years of landscape gardening, he wrote, "I have got a perfect situation and a perfect site for it." Letter from Church to Osborn, 29 July 1868, transcript, Olana Archive, Estate of Sally Good Church Papers.

9. These drawings may also date as early as 1867, since the floor plan does not seem to reflect Church's Middle Eastern architectural interest. They are in the collection of The American Institute of Architects Foundation, Prints and Drawing Collection, Washington, D.C.

10. The Century Club (Association) was founded in 1847 as a place where men with an interest in the arts might gather socially.

11. Calvert Vaux, *Villas and Cottages: A Series of Designs Prepared for Execution in the United States* (New York, 1857), xvi.

12. Vaux, 50.

13. Vaux, xvi.

14. For this information about Vaux's marriage and his relationship with clients, I am grateful to William Alex, President, The Frederic Law Olmsted Association.

15. Letter from Frederic Church to Erastus Dow Palmer, 13 May 1870, McKinney Library, Albany Institute of History and Art, Albany, New York.

16. Calvert Vaux, undated manuscript, Vaux Papers, New York Public Library. I am grateful to William Alex for this quotation from the document.

17. Letter from Frederic Church to Erastus Dow Palmer, 27 July 1870, McKinney Library, Albany Institute of History and Art, Albany, New York.

18. Letter from Frederic Church to John Ferguson Weir, 8 June 1871, Archives of American Art, roll 530, frame 32. Betsy Fahlman of Arizona State University uncovered this letter, which she passed on to Gerald Carr, who in turn allowed me to use it.

19. Pascal Coste, *Monuments Modernes de la Perse* (Paris, 1867) and Jules Bourgoin, *Les Arts Arabes* (Paris, 1868). Church's checkbook for 1869-1871 records the following 1870 expenditure: "Sep 1/at Christern/Book—Persian/Architecture—/80.00,"

Olana Archive, Estate of Sally Good Church Papers.

20. Lockwood de Forest, undated manuscript, Archive of American Art, roll 2730, frame 20.

21. Letter from Frederic Church to William H. Osborn, 7 November 1870, Olana Archive, Estate of Sally Good Church Papers.

22. "The Kaatskills, Their Attractions Enthusiastically Set Forth," undated clipping.

1. Henry Q. Mack diary, 1872, Vedder Library, Greene County Historical Society, Coxsackie, New York. The next two quotations about the house are from this same source.

2. and 3. Henry Q. Mack diary.

4. This description is partly based on a 4 June 1986 letter from William F. Wilson, architect, who discusses the floor plan of the house. I am grateful to Wilson for his insights.

5. Jervis McEntee Diary, entry for 22 June 1873, Archives of American Art, Roll D180.

6. According to Church's account book for 1869-1875, the cost of the house was $61,309.60. A recalculation of his expenses indicates that the correct total is $59,707.45. The account book is in the Olana Archive, Estate of Sally Good Church Papers, and I am grateful to Jane Churchill for recalculations.

7. Anne O'Connor, "Olana Stencil Analysis" (Report, Buffalo State College, Spring 1999), 3rd unnumbered page.

8. Letter from Grace King to May [?], 7 June 1889, Hill Memorial Library, Louisiana State University Libraries. A native of New Orleans, Grace King (1851-1932) was a "local color" writer who visited Olana with Samuel Clemens and Charles Dudley Warner.

9. Isabel Church, diary transcript, 1868, 64. Transcribed from a photostat of the diary at the New York Historical Society, New York, New York.

10. "The American Rhine," 11.

11. Numerous bills for furniture, china and kitchen equipment are in the Olana archives. Like most newly married couples, the Churches had to furnish an entire household. Correspondence from Church to his father indicates that his mother sent a dining room rug and pairs of curtains. Letter from Frederic Church to Joseph Church, 15 April 1864, Olana Archive, Estate of Sally Good Church Papers.

12. Church had brief contact with the "art" movement in England in the late 1860s. While in London during early December 1867, Church lunched with artist G. H. Boughton (1833-1905) and examined the work in his studio, (letter from Frederic Church to Erastus Dow Palmer, 10 March 1868, McKinney Library, Albany Institute of History and Art). Boughton was an occasional member of the Cranbrook Colony, a group of genre painters, whose best known member was J. C. Horsley (1817-1903). Norman Shaw (1831-1912) designed an addition to Horsley's Cranbrook house in 1864-1865, and designed a studio house for Boughton in 1877-1878. Andrew Saint points out that Shaw's early country house career began with commissions from painters. Saint writes that the painters "had their own judgement, could be expected to make a personal choice of architect, and often wished to participate in the making of the design." Andrew Saint, *Richard Norman Shaw* (New Haven, 1976), 36. Before their return to America in 1869, the Churches spent three additional weeks in London (from late May through mid-June). Considering his friendships in the artistic and literary world, Church was doubtless examining artistic interiors. The couple were feted continuously. Church wrote: "We are going through a course of diners [sic] etc. in London and my antiquated dress coat has a busy time of it." Letter from Frederic Church to his brother-in-law, Edward A. Weeks, 7 June 1869. Olana Archive, Estate of Sally Good Church Papers. Among Church's friends in London were Thomas Taylor, the art critic and editor of *Punch*, and Amelia Edwards, the Egyptologist and novelist. Further research would doubtless reveal more information about Church's

activities in England. Roger B. Stein, in his essay on the Aesthetic Movement, cites Olana as an early and very personal example of "the new artistic activity" in the United States. See Roger B. Stein, "Artifact as Ideology: The Aesthetic Movement in Its American Cultural Context," *In Pursuit of Beauty: Americans and the Aesthetic Movement* (New York, 1987), 24.

13. F. N. Zabriskie, "'Old Colony Papers'. An Artist's Castle and our Ride Thereto," *New York Christian Intelligencer*, 10 September 1884, Olana Research Collection.

14. The life of Lady Jane Digby El Mesrab is discussed by Lesley Blanch, *The Wilder Shores of Love* (New York, 1954), 133-203.

15. Isabel Church, diary transcript, 1868, 76.

16. Letter from Frederic Church to William H. Osborn, 4 February 1869, Olana Archive, Estate of Sally Good Church Papers.

17. Crates containing artifacts collected by the Churches were sent from Beirut and Constantinople. The total number of crates is discussed by the artist in correspondence with his brother-in-law. Letter from Frederic Church to Edward A. Weeks, 7 June 1869, Olana Archive, Estate of Sally Good Church Papers.

18. Tucker to Black, 16 May 1900. In this letter to Church's daughter, an elderly relative writes: "Shall I ever forget ... a visit to Olana when you were all children and there was every thing to make it an Earthly Paradise?" One important discussion of Olana's interior is in David C. Huntington, *The Landscapes of Frederic Edwin Church* (New York, 1966), 114-125.

19. David Huntington, "Frederic Edwin Church 1826-1900: Painter of the Adamic New World Myth" (Ph.D. diss., Yale University, 1960), 275.

20. Gerald Carr's research on the origin and meaning of the name Olana is published in Gerald Carr, *Olana Landscapes: The World of Frederic Church* (New York, 1989), 2.

21. Frederic Church, "Diary of a Journey to Petra, 1868," Olana Archive, Estate of Sally Good Church Papers. Gerald Carr discusses this association in his *Olana Landscapes*, 2.

22. Frederic Church to Amelia Edwards, 2 September 1877, Somerville College Library, Oxford, England. Amelia Edwards was a noted British Egyptologist whose work included *A Thousand Miles up the Nile* (London, 1877). Robin Eckerle and Joel Swiemler located this letter.

1. Lisbet Milling Pedersen and Henrik Permin, "Rheumatic Disease, Heavy-Metal Pigments, and the Great Masters," *The Lancet* (4 June 1988), 1267. This article discusses the exposure of artists "to mercury sulphide, cadmium sulphide, arsenic sulphide, lead, antimony, tin, cobalt, manganese, and chromium, the metals of the bright and clear colors." The authors go on to say that "exposure to these metals may be of importance in the development of inflammatory rheumatic diseases." Also: Philip L. Cohen, "The Arthritis of Frederic E. Church," *Journal of Rheumatology,* 74, no. 7 (1997): 1453-1454.

2. Isabel wrote her daughter: "I think we should try to remain in our own home—here father will go to the studio and paint, in New York he will only lie on the sofa—and think of his various symptoms." Letter from Isabel Church to Downie Church Black, 17 January 1887, Olana Archive, Estate of Sally Good Church Papers.

3. Letter from Frederic Church to Martin Johnson Heade, 22 September 1885, Archives of American Art.

4. Zabriskie, 2. While touring Olana, Zabriskie observed that "We saw but one of Mr. Church's own great works, his striking picture of the rock temple at Petra, the remainder being sketches and studies."

5. Letter from Frederic Church to Erastus Dow Palmer, 7 July 1869, McKinney Library, Albany Institute of History and Art.

6. Letter from Frederic Church to Charles De Wolf Brownell, 7 June 1888, Olana Research Collection.

7. Letter from Frederic Church to Erastus Dow Palmer, 11 September 1888, McKinney Library, Albany Institute of History and Art.

8. Two bills from George Siegel, a New York City furniture manufacturer and dealer, document this move. The bills are dated 10 January 1889 and 8 January 1890. Olana Archive, Estate of Sally Good Church Papers. The packing list indicates that Church had few objects and no paintings in the studio. The studio had been sublet to other artists for a number of years.

9. Letter from Frederic Church to Erastus Dow Palmer, 19 April 1891, McKinney Library, Albany Institute of History and Art. This painting is in the Carnegie Institute, Pittsburgh.

10. Joel Sweimler, "Evidence of Room Use and Original Furnishings—Studio," *The Furnishing Plan for Olana State Historic Site,* c. 1990 draft, Olana Research Collection.

11. Letter from Frederic Church to Erastus Dow Palmer, 18 October 1884, McKinney Library, Albany Institute of History and Art.

12. Information in this section is drawn from several reports commissioned by the Bureau of Historic Sites, New York State Office of Parks, Recreation and Historic Preservation and Friends of Olana, Inc.: Robert Toole, "Historic Landscape Report, Phase One," 31 August 1984; Ellen McClelland Lesser, "Historic Landscape Research Report, Phase Two," 1 June 1986; Ellen McClelland Lesser, "Landscape Research Report, Phase Three," 15 September 1986; and R. M. Toole and Ellen McClelland Lesser, "Master Restoration Plan, Phase Four, Part One, Mansion Environs," 15 August 1988, Olana Research Collection.

13. An extended discussion of the relationship between the house and landscape and sky is in D. Seamon, "Presenting Sense of Place to the Public: Background Planning for an Introductory Multi-Media Exhibit for American Landscape Painter Frederic Church's *Olana,*" Final Report, National Endowment for the Arts, Design Arts Program, Grant No. 91-4216-0038, (1992). Olana Research Collection.

14. R. M. Toole, "Draft Proposal for Master Restoration Plan, Phase Four, Part Two, South Park," 15 November 1988. Olana Research Collection.

15. The lake also served a practical function. From it ran underground pipes that provided water for the vegetable garden and for livestock in the barns. In addition, a steam engine housed near the lake pumped water to the house for non-drinking uses.

16. Letter from Frederic Church to Edward A. Weeks, 13 October 1869, Olana Archive, Estate of Sally Good Church Papers.

17. Bonnelle, 17.

18. Zabriskie, 2.

19. Zabriskie, 2.

20. Zabriskie, 2. The author continues: "The expenditure in road-building, and in otherwise bringing this huge, wild, steep mass of earth into suitable shape and condition, has been immense, and could not have been accomplished by the Bohemian type of artist, whose wealth is purely in aesthetic securities and whose castles are all in Spain."

1. Letter from Grace King to Nan [?], 4 August [?], 1891, Hill Memorial Library, Louisiana State University Libraries, Baton Rouge, Louisiana.

2. Bonnelle, 17.

3. Letter from Louis Church to Frederic Church, 26 October 1891, Olana Archive, Estate of Sally Good Church Papers.

4. Letter from Isabel Church to Downie Church Black, 13 December 1891, Olana Archive, Estate of Sally Good Church Papers.

5. Bonnelle, 17.

6. Frederic Church, "Last Will and Testament," 9 January 1890, Olana Archive, Lark Papers. The signature is excised from this document, thus invalidating it.

7. Frederic Church, "Last Will and Testament," 22 July 1899, Olana Archive, Estate of Sally Good Church Papers.

8. Letter from Frederic Church to Mrs. Virginia Osborn, 7 December 1899, Olana Archive, Estate of Sally Good Church Papers.

9. "Mr. Church Dies," undated and unidentified newspaper obituary, Olana Archive, Estate of Sally Good Church Papers.

10. "The American Rhine," 17.

1. *Paintings by Frederic E. Church* [no author] [exhibition catalogue](New York: Metropolitan Museum of Art, 1900), unpaginated; quoted in Franklin Kelly, "A Passion for Landscape: The Paintings of Frederic Edwin Church," in *Frederic Edwin Church* (Washington, D.C., 1989), 68.

2. David Huntington, *The Landscapes of Frederic Edwin Church: Vision of an American Era* (New York, 1966). On the shifting scholarly and popular perceptions of Church's work, see Franklin Kelly, "Introduction," in *Frederic Edwin Church*, 12-16 (note 1). On the same topic for the Hudson River School as a whole, see Kevin Avery, "A Historiography of the Hudson River School," in *American Paradise: The World of the Hudson River School* (New York, 1987).

3. Attended by a standing-room-only audience of 800 people, the auction of the painting took only three minutes and forty-five seconds. Bidding started at $500,000 and advanced in $50,000 increments. For an assessment of the auction, see Gerald L. Carr, *Frederic Church's The Icebergs* (Dallas, 1980), 8-9.

4. The expression "last great work" is from J. Carter Brown, "Foreword," in *Frederic Edwin Church* (see note 1), 8.

5. Unless indicated otherwise, the information presented here on Louis and Sally's stewardship of Olana is drawn from Karen Zukowski, *The Historic Furnishings Report for Olana State Historic Site: A History of the Interiors, Thoughts on Their Significance, and Recommendations for the Restoration*, report for the New York State Office of Parks, Recreation and Historic Preservation and The Olana Partnership, 2001.

6. The cottage in Florida was demolished in 1996. See Daniel Chiat, "Quick Action Documents Church History," *The Crayon* [newsletter of Friends of Olana], vol. 27, no. 202 (Spring, 1996), 1 and 16.

7. Dorren Martin, 1997, "A Chronological Outline of Architectural Alterations to the Main Church Family Residence at Olana State Historic Site, April 7, 1900 through June 30, 1966," report for Olana, 1997, unpaginated, Olana Research Collection.

8. Martin, unpaginated.

9. Interview with Helen Howe, Dot Wilsey, and Dorthea Wentworth [former Olana servants], by James Ryan and Karen Zukowski, August 13, 1991, transcript, 57-58, Olana Research Collection.

10. Martin, unpaginated; Zukowski, *Historic Furnishings Report*, 121.

11. Interview with David Huntington by Dr. Charles Hosmer, Principia College, Elsah, Illinois, 1988, 15. One of a series of oral history interviews with outstanding figures in the field of historic preservation. Transcript, Olana Research Collection.

12. David Huntington, "Frederic Edwin Church, 1826-1900: Painter of the Adamic New World Myth."

13. Interview with David Huntington, 7-8.

14. In his 1988 interview (see note 11), Huntington provides a striking account of his first meeting with Boice: "I was ... madly photographing [in the East Parlor], and I heard a voice in the hall say, 'Do you see this? Do you see that? These have been here for a hundred years. They should stay here. They belong here.' And I walked out into the hall, and it was Lloyd Boice talking. ... I'd known Boice's name ever since I first went to Olana ... but we'd never met. ... I had never had the slightest hint that Boice was somebody who cared about things like this at

all. ... I went out to introduce myself ... [and we] sat down in the kitchen and began planning a strategy. He had very good connections with Albany" (18-19).

15. The other trustees of Olana Preservation were Frederic H. Osborn (Honorary Chairman), Mrs. William H. Osborn (Vice-Chairman), David Huntington (Vice-President), James Biddle (Treasurer), Raymond Kennedy (Secretary), Albert S. Callan, Jr., Lammot du Pont Copeland, Mrs. Lammot du Pont Copeland, Henry F. du Pont, Donald Karshan, Frank McCabe, J. William Middendorf II and Roland L. Redmond.

Other individuals who played an important role in saving Olana included: Winthrop Aldrich, Raymond Beecher, Edward Casserly, Betty Cunningham, John L. Edwards, Elizabeth Aldrich Elliott, Beverly Finn, Mrs. Joseph P. Gold, Inge Henckel, August Heckscher, Gertrude Huntington, Henry James, Philip Johnson, Edgar Kaufmann, Anna Kennedy, Robert F. Kennedy, Henry Livingston, Maria Livingston, Lincoln Kirstein, Gus Kramer, Charles Lark, Jr., Reverend James Elliott Lindsley, Russell Lynes, Hillary Masters, Mary Mazzacano, Dorothy Miller, Marion Neefus, Herman Oswald, Alan Porter, Joseph Resnick, Lilian Reineck, Edith Saville, Vincent Scully, Russell Sigler, Mabel Parker Smith, Mrs. Kempner Thorne, and Carl Weinhardt.

16. David Huntington and Richard Wunder, *Frederic Edwin Church* [exhibition catalogue] (Washington, D.C.: National Collection of Fine Arts, Smithsonian Institution, 1966).

17. Huntington, *The Landscapes of Frederic Edwin Church*. On the significance of David Huntington's work in saving Olana, see "David Huntington, 1922-1990: A Florilegium," special issue of *The Crayon* [newsletter of Friends of Olana], vol. 24, no. 196 (Winter, 1991).

18. Interview with David Huntington, 35.

19. Published by Cambridge University Press in 1994.

A Chronology of Frederic Church and Olana

This chronology documents key events in Church's life that directly or indirectly relate to his creating and living at Olana. For a more extensive Church chronology, see D. Rindge, "Chronology," in *Frederic Edwin Church* (Washington, D.C.: National Gallery of Art, 1989). Many of the entries here are drawn from Rindge's chronology.

1826 4 May. Born in Hartford, Connecticut, to Joseph Edward and Eliza Janes Church.

1844 Moves to Catskill, New York, to study with Thomas Cole until 1846.

1845 May. Cole takes Church across the Hudson to sketch the extraordinary views from a high shale bluff called Red Hill directly across the river from Cole's home, *Cedar Grove*, in Catskill.
Completes *Twilight among the Mountains (Catskill Creek)*, one of his earliest paintings of the Catskills.
Exhibits publicly for the first time at the National Academy of Design in New York City.

1848 11 February. Unexpected death of Thomas Cole in Catskill, New York; Cole dies of pneumonia at the age of forty-seven.

1857 Completes *Niagara*. First exhibited in April at the gallery of Williams, Stevens, Williams, New York, to enthusiastic reviews; establishes Church's reputation.

1859 Completes *Heart of the Andes*. Sold for $10,000, the highest price at that time ever paid for a painting by a living American artist.

1860 31 March. Purchases Wynson Breezy farm about five miles south of Hudson, New York. The property adjoins Red Hill where Church had sketched with Cole in 1845.
14 June. Marries Isabel Carnes.
November. Moves to his new property, which he and Isabel call "the Farm."
Begins planting trees.
Completes *Twilight in the Wilderness*.

1861	Completes construction of a modest board-and-batten cottage, designed by architect Richard Morris Hunt. The Churches occupy the house, called "Cosy Cottage," in May or June. Completes *The Icebergs*.
1862	29 October. Birth of first child, Herbert Edwin (d. 1865). Completes *Cotopaxi*.
1864	22 October. Birth of second child, Emma Francis (d. 1865). Around this time, erects a large wood-frame studio at the topmost boundary of his property on Long Hill. Between 1861 and the 1890s, Church repeatedly sketches the remarkable panoramas.
1865	18 March. Death of his son Herbert Edwin of diphtheria, age two. 26 March. Death of his daughter Emma Francis of diphtheria, age five months. To assuage their grief, Church and his wife travel to Jamaica for four months. Completes *Aurora Borealis*.
1865	30 September. Birth of third child, Frederic Joseph (d. 1914).
1867	15 January. Death of his younger sister, Charlotte Eliza. Purchases eighteen acres on the forested summit of Long Hill above the Farm, future site of the main house at Olana. Late October or early November, departs New York for a nineteen-month trip to Europe and the Middle East with his wife, his infant son Frederic, and his mother-in-law Emma Carnes.
1868	January. Arrives in Beirut and is greatly attracted to the houses, especially their central courtyards.
1869	22 February. Birth of fourth child, Theodore Winthrop (d. 1914) in Rome. Church experiences the start of crippling rheumatism.
1870	30 April. Birth of fifth child, Louis Palmer (d. 1943). Through 1872, the construction of the main house atop the summit of Long Hill. By May, Calvert Vaux replaces Richard Morris Hunt as consulting architect. By November, Church has clarified design and construction of house as a whole.
1871	17 July. Birth of sixth and last child, Isabel Charlotte, nicknamed "Downie" (d. 1935).
1872	Probably late in the year, the family occupies the second story of the new house. Decoration of first-floor rooms begins. Completion of woodwork and painted decoration takes four years.
1873	Lake excavated from the swampy stream at the foot of Long Hill is completed. Edges echo the shape of the Hudson.
1874	Completes *El Khasné Petra*.
1876	14 February. Death of his father.

1877 Completes *Morning in the Tropics*, his last major picture.

1880 Church's estate now called Olana.
From 1880 through 1900, Church paints and sketches only sporadically. Winters spent in Mexico; summers divided between Olana and Lake Millinocket, Maine, where the family built a summer camp about 1876.

1883 17 July. Death of his mother.

1885 Starts improvements on the house interior that include parquet flooring, carved Indian fireplace fronts, and stencils for the pillared screen on the stair landing.

1886 Death of his older sister, Elizabeth Mary. Church inherits a large number of his own works collected by his parents, including *Autumn* (1856) and *The After Glow* (1867). Also acquires two paintings by Thomas Cole—*A Solitary Lake in New Hampshire* (1830) and *View of the Protestant Burying Ground, Rome* (c.1834).

1888 Begins studio wing that includes connecting corridor, observatory, bedroom, and storage.

1889 Closes his New York City studio that he had rented for thirty years and ships contents to Olana.

1891 Completes studio wing. Late in the year, twenty-one-year-old son Louis becomes salaried manager of the Farm.

1899 12 May. Death of his wife Isabel. Writes a will bequeathing Olana to Louis. Winters in Mexico with Louis.

1900 March. Returns to New York in poor health.
7 April. In New York, dies at age seventy-three in the home of his late friend and patron William H. Osborn.
Buried next to his wife in Spring Grove Cemetery, Hartford, Connecticut.
28 May-15 October. Memorial exhibition at the Metropolitan Museum of Art, New York City.

1901 In January, Louis Church and Sarah Baker Good, known as "Sally," marry in Lock Haven, Pennsylvania. After several months honeymooning in Europe, the couple settle at Olana, where they live the rest of their lives.

1917 Louis and Sally donate over 2,000 pencil and oil sketches by Frederic Church at Olana to the Cooper-Hewitt Museum in New York City.

1943 8 November. Louis dies in his Olana bedroom, age seventy-three.

1947 Germantown realtor Lloyd Boice is hired as an overseer of the Olana property.

1953 December. Art historian David Huntington, conducting research for his dissertation on Church, visits Olana for the first time.

1960 Sally Church at age ninety-two is declared mentally incompetent.

1964 17 August. Sally Church dies peacefully in her sleep. She had resided at Olana for sixty-three years.
Sally's nephew, Charles Lark, Jr., inherits Olana.
Early September. David Huntington learns that Olana and its contents are to be auctioned.
11 November. Olana Preservation, Inc., is formed with Alexander Aldrich as president.

1965 Olana Preservation signs a lease on Olana with an agreement to purchase the property for $470,000.

1966 David Huntington's *The Landscapes of Frederic Edwin Church* published.
February. David Huntington and curator Richard Wunder organize an exhibition of Church's works at the National Collection of Fine Arts, Smithsonian Institution.
Mid-May. *Life* magazine article on Olana.
22 June. New York State Legislature passes bill authorizing State of New York to purchase Olana.
27 June. Governor Nelson Rockefeller signs the bill into law at Olana.
29 July. Olana Preservation purchases Olana.
13 December, conveys title to the State of New York.

1967 3 June. Olana opens to the public as a New York State Historic Site. Richard Slavin is the first site manager.

1971 28 May. Friends of Olana, Inc., granted a charter by the New York Board of Regents.

2000 Friends of Olana becomes The Olana Partnership.

BIBLIOGRAPHY

This list includes works relating directly to Church and Olana as well as entries that discuss Church or the Hudson River School in broader terms.

Apostolos-Cappadona, D., 1995. *The Spirit and the Vision: The Influence of Christian Romanticism on the Development of 19th-Century American Art.* Atlanta: Scholars Press.

Ashbery, J., 1997. "Frederic Church at Olana: An Artist's Fantasy on the Hudson River." *Architectural Digest*, 54 (June), 60, 62, 70, 74, 78.

Aslet, C., 1983. "Olana, New York State," parts I and II, *Country Life*, 22 and 29, September, 761-765, 839-842.

Avery, K. J., 1993. *Church's Great Picture: The Heart of the Andes.* NY: Metropolitan Museum of Art.

Belanger, P. J., 2000. *Inventing Acadia: Artists and Tourists at Mount Desert.* Rockland, Maine: Farnsworth Art Museum.

Calloway, S., 1992. "Two Nineteenth-Century Painters Created Their Own Exotic Worlds," *HG [House and Garden]*, February, 100-104, 139.

Carr, G. L., 1980. *Frederic Edwin Church: The Icebergs.* Dallas, TX: Dallas Museum of Fine Arts.

Carr, G. L., 1989. *Olana Landscapes: The World of Frederic E. Church.* NY: Rizzoli.

Carr, G. L., 1990. "Master and Pupil: Drawings by Thomas Cole and Frederic Church." *Bulletin of the Detroit Institute of Arts* 66, 47-60.

Carr, G. L., 1994. *Frederic Edwin Church: Catalogue Raisonné of Works of Art at Olana State Historic Site*, 2 vols. NY: Cambridge University Press.

Carr, G. L., 2000. *Frederic Edwin Church: In Search of the Promised Land.* NY: Berry-Hill.

Cooper, J. F., 1999. *Knights of the Brush: The Hudson River School and the Moral Landscape.* NY: Hudson Hills Press.

Creese, W. L., 1985. *The Crowning of the American Landscape: Eight Great Spaces and Their Buildings.* Princeton: Princeton University Press.

Davis, J., 1987. "Frederic Church's 'Sacred Geography'." *Smithsonian Studies in American Art* 1 (spring), 79-96.

Davis, J., 1996. *The Landscape of Belief: Encountering the Holy Land in Nineteenth-Century American Art and Culture.* Princeton: Princeton University Press.

Dee, E. E., 1984. *To Embrace the Universe: Drawings by Frederic Edwin Church*. Yonkers, NY: Hudson River Museum.

Dee, E. E., 1992. *Frederic Edwin Church - Under Changing Skies: Oil Sketches and Drawings from the Collection of the Cooper-Hewitt, National Museum of Design, Smithsonian Institution*. Philadelphia: Arthur Ross Gallery, University of Pennsylvania.

Edwards, H., 2000. *Noble Dreams, Wicked Pleasures; Orientalism in America, 1870–1930*. Princeton University Press/Clark Art Institute.

Goss, P. L., 1976. "Olana—the Artist as Architect," *Antiques*, 110, 764-775.

Haskell, A. H., 1989. "Once upon a Time at Olana," *Arts and Antiques*, 6, February, 64-71.

Howat, J., 1972. *The Hudson River and Its Painters*. NY: American Legacy Press.

Howat, J., 1987. *American Paradise: The World of the Hudson River School*. NY: Metropolitan Museum of Art.

Huntington, D., 1960. "Frederic Edwin Church, 1826-1900: Painter of the Adamic New World Myth." Ph.D. dissertation, Yale University.

Huntington, D., 1966. *The Landscapes of Frederic Edwin Church: Vision of an American Era*. NY: George Braziller.

Huntington, D., 1980. "Church and Luminism: Light for the Elect," in J. Wilmerding, *American Light: The Luminist Movement, 1850-1875*. Washington, D. C.: National Gallery of Art.

Huntington, D. and Wunder, R., 1966. *Frederic Edwin Church*. Washington, D.C.: National Collection of Fine Arts, Smithsonian Institution.

Kelly, F., 1985. "Frederic Edwin Church and the North American Landscape, 1845-60." Ph.D. dissertation, University of Delaware.

Kelly, F., 1988. *Frederic Edwin Church and the National Landscape*. Washington, D.C.: Smithsonian Institution Press.

Kelly, F., 1989. *Frederic Edwin Church*. Washington, D.C.: National Gallery of Art.

Manthorne, K., 1985. *Creation and Renewal: Views of Cotopaxi by Frederic Edwin Church*. Washington, D.C.: National Museum of American Art, Smithsonian Institution.

Manthorne, K., 1989. *Tropical Renaissance: North American Artists Exploring Latin America, 1839-1879*. Washington, D.C.: Smithsonian Press.

Parry, E. C., 1988. *The Art of Thomas Cole: Ambition and Imagination*. Newark: University of Delaware Press.

Petrich, C. H., 1984. "EIA Scoping for Aesthetics: Hindsight from the Greene County Nuclear Power Plant EIS," *Improving Impact Assessment*, ed. S. L. Hart, G. A. Enk, and W. F. Hornick. Boulder, Co.: Praeger, 57-92

Phillips, S. S., 1988. *Charmed Places: Hudson River Artists and Their Homes, Studios, and Vistas*. New York: Harry N. Abrams.

Ryan, J. A., 1984. "The Olana State Historic Site Master Plan," Master's thesis, Cooperstown Museum Graduate Program, State College of New York at Oneonta.

Ryan, J. A., 1989. "Frederic Church's Olana: Architecture and Landscape as Art," *Frederic Edwin Church*, ed. F. Kelly. Washington, D. C.,: Corcoran Gallery of Art, 126-156; reprinted in revised form in this volume.

Scully, V., 1965. "Palace of the Past," *Progressive Architecture*, 185-189.

Seamon, D., 1992. "Presenting Sense of Place to the Public: Background Planning for an Introductory Multi-Media Exhibit for American Landscape Painter Frederic Church's Olana," Final Report,

National Endowment for the Arts, Design Arts Program, Grant No. 91-4216-0038.

Seamon, D., 1992. "A Diary Interpretation of Place: Frederic Church's Olana," ed. D. Janelle, *Geographical Snapshots of North America*. NY: Guilford Press.

Stebbins, T. E., 1978. *Close Observation: Selected Oil Sketches by Frederic E. Church*. Hartford, CT: Wadsworth Atheneum.

Stein, R. B., 1987. "Artifact as Ideology: The Aesthetic Movement in its American Cultural Context," *In Pursuit of Beauty: Americans and the Aesthetic Movement*, ed. R. B. Stein. NY: Rizzoli, 21-30.

Sweeney, J. G., 1988. "'Endued with Rare Genius': Frederic Edwin Church's *To the Memory of Cole*," *Smithsonian Studies in American Art* 2 (winter), 45-71.

Toole, R. M., 1996. *Historic Landscape Report: Olana State Historic Site, Hudson, New York*. Unpublished report.

Zukowski, K., 1999. "Creating Art and Artists: Late Nineteenth-Century American Artists' Studios," doctoral dissertation, Graduate Center of the City University of New York.

Zukowski, K., 2000. *The Historic Furnishings Report for Olana State Historic Site: A History of the Interiors, Thoughts on Their Significance, and Recommendations for the Restoration*. Report for the NYS Office of Parks, Recreation and Historic Preservation and Friends of Olana.

THE CONTRIBUTORS

The late *James Anthony Ryan* was the site manager at Olana State Historic Site from 1979 until shortly before his death in 1999. He was born in Kansas City, Missouri, in 1942, and graduated from the University of Notre Dame in 1966 with a degree in American intellectual history. He earned a Master's degree in museum administration from the Cooperstown Graduate Program in 1977, the same year he became site manager for the Senate House State Historic Site in Kingston, New York.

Two years later, he became site manager of Olana, which under his twenty years of directorship became one of the most significant artist's homes and studios, both nationally and internationally. What was perhaps most singular about Ryan was his unselfish, unstinting love of history, art, architecture, and decorative objects. At Olana, his pleasure in the place made people feel deeply its historical and artistic uniqueness. Ryan had an extraordinary zest for living and used it in wonderful ways to enrich the lives of others.

Katherine Hopkins, *James Ryan and His Cat Lucy*, 1994.

Franklin Kelly is Curator of American and British Paintings at the National Gallery of Art in Washington, D.C. and Associate Professor of Art History and Archaeology at the University of Maryland. A specialist on the work of Frederic Edwin Church, he has also published and lectured on a variety of other American artists, including Thomas Cole, Asher B. Durand, Fitz Hugh Lane, Martin Johnson Heade, Winslow Homer, Thomas Eakins, George Bellows, Edward Hopper and Charles Sheller.

David Seamon is an environment-behavior researcher and Professor of Architecture at Kansas State University. With James Ryan, he wrote the introductory exhibit panels in Olana's visitors' center and also contributed to the writing of the film that introduces visitors to the site. He recently wrote the text for the introductory exhibit at Thomas Cole's Cedar Grove in Catskill, New York, directly across the Hudson from Olana.

Karen Zukowski is an independent historian specializing in the art and culture of late-nineteenth-century America. She was formerly the curator of Olana where she wrote the Historic Furnishings Report, which documents and catalogs the original furnishings of the public rooms of the main residence at Olana. She has worked in historic houses and art museums, and published on painting, decorative arts, interiors and historic house management. She holds a Ph.D. from City University of New York, with a dissertation on late-nineteenth-century American artists' studios.

INDEX

OLANA

Olana is one of five historic sites and twelve parks administered by the New York Office of Parks, Recreation and Historic Preservation, Taconic Region.

The Olana Partnership, formerly Friends of Olana, is a private-not-for-profit organization, which works cooperatively with New York State to support the preservation, restoration, development and improvement of Olana State Historic Site.

Olana is a designated National Historic Landmark.

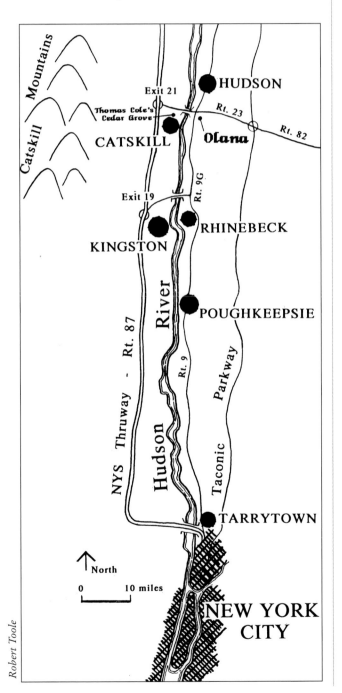

Robert Toole

HOUSE TOURS

Available April through October, Wednesday through Sunday.

LANDSCAPE

Visitors are welcome to stroll the 250-acre picturesque landscape year-round from sunrise to sunset.

ORIENTATION CENTER

Olana's orientation center and museum shop are open daily April through October, during regular site hours. An exhibit and audiovisual program on Olana and the Church family are featured.

TELEPHONE: (518) 828-0135
WEBSITE: www.olana.org

DIRECTIONS

To Olana State Historic Site, Route 9G, 1 mile south of the Rip Van Winkle Bridge.

From the North

Take NYS Thruway (Route 87) south to Exit 21, Catskill. Follow signs for Route 23 East and Hudson. Cross Rip Van Winkle Bridge, bear right onto Route 9G south. Olana is 1 mile south of bridge on left.

Or, take Route 9W to Catskill, then take Route 23 east. Cross the Rip Van Winkle Bridge and bear right onto Route 9G south. Olana is 1 mile south of Rip Van Winkle Bridge on left.

Or, take Route 9 south to Route 9G Hudson. Continue on 9G approximately 3-4 miles. Olana is 1 mile south of Rip Van Winkle Bridge on left. (Do not cross bridge).

From the South

Take NYS Thruway (Route 87) to Exit 21, Catskill. Follow signs for Route 23 east and Hudson. Cross Rip Van Winkle Bridge and bear right onto Route 9 south. Olana is 1 mile south of Rip Van Winkle Bridge on left.

Or, take NYS Thruway (Route 87) to Exit 9 (Route 9). Take Route 9 north to Route 9G at Rhinebeck. Stay on Route 9G for approximately 20 miles. Olana will be on right.

Or, from New York City, take the Taconic State Parkway to Hudson Exit, Route 82 north. Follow Route 82 north to Route 23 West to Route 9G south. Olana is 1 mile south of Rip Van Winkle Bridge on left.

From the East

Take Massachusetts Turnpike to NYS Thruway (Route 90 West) to Exit B2. Take Taconic State Parkway south to Route 23 west. Continue on Route 23 west to Route 9G south. Olana is 1 mile south of Rip Van Winkle Bridge on left. (Do not cross bridge).

Or, take the Taconic State Parkway north to Hudson Exit (Route 82 North) to Route 23 west. Continue on Route 23 west to Route 9G south. Olana is 1 mile south of Rip Van Winkle Bridge on left. (Do not cross bridge).